THE
RAVISHED
IMAGE

THE RAVISHED IMAGE

or
How to Ruin Masterpieces by Restoration

SARAH WALDEN

St. Martin's Press
New York

Library of Congress Cataloging in Publication Data

Walden, Sarah.
 The ravished image.

 1. Painting—Conservation and restoration.
I. Title.
ND1650.W35 1985 751.6'2 85-12511
ISBN 0-312-66416-8

First published in Great Britain by George Weidenfeld & Nicolson Ltd.

First U.S. Edition

10 9 8 7 6 5 4 3 2 1

CONTENTS

ILLUSTRATIONS

ACKNOWLEDGEMENTS

I would like to thank firstly my husband, George, without whose help, inspiration and encouragement at all stages, this book would not have existed; my children, Oliver, Francis and Celia, for their tolerance about the time that it took from them, and my father, Dr Thomas Hunt, whose respect for human values in the practice of medicine was another source of inspiration.

Secondly I wish to thank Sir Ernst Gombrich, not only for the contribution of a foreword, but also for the stimulation and enlightenment from all his work and efforts in this delicate area. Amongst other writings in the field I am particularly grateful to M. Guillerme, whose *L'Atelier du Temps* is an impressive mine of historical research, and to Walter Kaiser for his thought-provoking article 'Time is an Artist'. The Forbes Library at the Fogg Museum, Harvard University, was a rewarding source of earlier books not generally available. The chief restorers at the Hermitage in Leningrad and at the Pushkin Museum in Moscow provided me with invaluable reflections and evidence of thoughtful and sensitive work. The experience of working with the craftsmen, art historians and administrators of the Louvre has also been immensely enriching. Denys Sutton also kindly looked over the book with his discriminating eye.

Thirdly I owe a debt of gratitude, for their very practical help, to Molly Tattershall and Shana Hole, who tackled the typescript with patience and perceptiveness.

The extracts from Professor Sir Ernst Gombrich's article 'Variations on a Theme from Pliny' (February 1962) and from Cesare Brandi's article 'The Cleaning of Pictures in Relation to Patina, Varnishes and Glazes' (July 1949) are reproduced by kind permission of the *Burlington Magazine*. I am grateful to the Controller of Her Majesty's Stationery Office for permission to reproduce an extract from the 1980 Report by a Working Party, *Conservation – Museums and Galleries* and to Faber and Faber for permission to quote from *The Cleaning of Paintings* by Helmut Ruhemann.

FOREWORD

Members of the older generation of art lovers in this country may still remember a particularly virulent outbreak of those periodic 'cleaning controversies', centering on the National Gallery in 1962, and ending, like all previous ones, in the defeat of the critics of that great institution – defeat in the sense that the Trustees ignored the pleas which had reached them from many quarters, and decided to send Titian's *Bacchus and Ariadne* to the laboratory to be subjected to a kind of treatment that seemed to some of us to be unsound. Nobody will be able to tell after so many years how far our fears proved justified, and whether an indefinable *je-ne-sais-quoi* was or was not lost in the expression of the god who leaps from the chariot in pursuit of Ariadne. Since such matters may well lie outside the range of scientific proof, I have seen no point in publicly voicing my anxieties, all the less as I could not reveal how many conservators had privately expressed their agreement with my lines of argument but did not want to be quoted.

I was all the more happy to encounter in the author of this book a practising conservator of high standing who is

1

convinced that the time has come to alert the public to certain dangers incurred in the so-called 'cleaning' of paintings. Since Mrs Walden so clearly knows what she is talking about, it would be redundant for me as an art historian simply to call out 'hear, hear' whenever she makes a point reinforcing my own convictions. Instead, I would rather raise the question of why it is that the common-sense view in this matter has to fight against such heavy odds?

Maybe some of the observations made in the psychology of picture perception could be relevant here. I venture to recall certain considerations I raised at the end of my book on *Art and Illusion*, considerations connected with that tendency of the human mind which the great psychologist F. C. Bartlett called the 'effort after meaning' – our desire to make sense of what we perceive, and rather to guess than give up the search. I suggested that there is a hidden corollary to this tendency – a certain unwillingness to accept what I called 'ambiguity', but should perhaps have described as 'indeterminacy'. I mentioned that I had learned about this unconscious bias from a friend who had been one of the pioneers of X-ray photography, the late Gottfried Spiegler, who incidentally had placed his novel skill in the service of the investigation of paintings under Johannes Wilde at the Vienna Kunsthistorisches Museum. Spiegler had come across this built-in intolerance in the assessment of X-ray negatives. He noticed that to be classed as 'good' these images had to look crisp, clear and well defined, whereas in fact these superficial qualities often impeded rather than aided a correct diagnosis, particularly where the actual morbid conditions had led to blurrings and indeterminate transitions. He even developed a process he called *anti-dur* to counteract excessive contrasts in negatives which might otherwise have masked those all-important softenings of certain outlines.

Maybe this psychological observation, from a field

wholly unaffected by aesthetic fashions, historical pre-judices or pride of display, reinforces the arguments the reader will find in this book. Mrs Walden is the last to deny that dust, grime and opaque varnishes have to be removed in the interest of conservation, and she is of course frequently engaged in such vital rescue operations. There is much of great interest to be learned about these matters from her book. But it is precisely in these delicate proced-ures that the conscientious conservationist must be especi-ally on guard against that intolerance of ambiguity that led a prominent practitioner to deny – in the face of incon-trovertible evidence – that the deliberate blurring of out-lines had a place in the repertory of Renaissance painters. My presentation of further testimonies which I published in the *British Journal of Aesthetics* (Vol. 2 No. 2, April 1962) under the title 'Blurred Images and the Unvarnished Truth' fell on deaf ears, or rather on closed minds. It is to be hoped that by now the climate of opinion has sufficiently changed so that the author's reasoned pleas for caution in these vital matters will at least be accorded a sympathetic hearing. In the responsible art of picture conservation, scientific and historical knowledge, manual skill and a sensitive eye must combine with the rarest of all the virtues – humility. The word restoration is generally a misnomer. We can never turn back the wheels of time. Thus we simply must not pander to the wish of hurried tourists who want to take in every work of art in passing. In seeking to lift the seven veils that hide and reveal the multiple suggestions embod-ied in the masterpieces of the past, we must not further contribute to the irreparable impoverishment of our dwindling artistic heritage.

E. H. Gombrich
London, July 1984

INTRODUCTION

Some on the leaves of ancient authors prey;
Nor time nor moth e'er spoiled so much as they.
Pope, *An Essay on Criticism*

How would Titian or Leonardo feel if they were to
wander into one of the great picture galleries of the
modern world? They might not recognise some of their
own paintings at first sight. And having discovered
them, after polite enquiry, they might be at first puzzled,
then indignant. They would understand the need to
remove their works from the church or palace they had
been painted for, into art galleries. As practical men, they
would be unsurprised by the vicissitudes their pictures
had suffered as they passed from hand to hand over the
centuries. They would be philosophical about the effects
of time on paint and canvas, and would already be quite
familiar with the problem of darkening varnish. But they
would be appalled at the man-made ravages inflicted on
their works.

The subjects of the paintings would still be recognisable;

5

they would still tell the same 'story'. But our supreme craftsmen would be far more interested in the painted surface itself, with its layers of delicate touches, balancing of colour and tone, and subtle glazings. They would ask with some consternation what had happened to these most intricate and precious aspects of their art, on which they had lavished their finest talent.

And indeed, many of their paintings have become ghosts: two-dimensional shadows of their former selves, identifiable in outline but carrying only a faint aesthetic echo of the original. In extreme cases they may even seem to have more in common with the reproductions in the museum shop than with great art. The discerning eye of our great masters would notice uncanny similarities between the condition of some of their works and the ideals of photography.

The same starkness of colour, flatness of plane, and homogenised texture that makes the camera the focus around which twentieth-century art rotates, would seem to have somehow imprinted themselves retrospectively on the art of the past as well. This impression would be no mere fanciful delusion, but a physical fact. From their own experience of the problems and pitfalls of conservation, our painters would soon detect the busy hand of the twentieth-century restorer; and they would be right.

Leonardo, the polymath, would be especially dismayed. The absorbing curiosity of his own mind had led him into many fields of scientific experimentation and invention. He would at first be thrilled and fascinated by the accomplishments of his twentieth-century successors. But he would be disturbed to discover that these new developments had brought a new arrogance, from which nothing – including works of art – was immune. The humanistic unity between arts and sciences, symbolised by the Renaissance itself and exemplified by Leonardo's own achievements, would have disappeared.

He might demand to confront the technicians responsible. Imagine his dismay as he enters the restoration department of a large modern gallery. As one of the earliest experimenters in anatomical dissection, Leonardo might be struck by how much more these facilities had in common with the surgery than the studio. The paintings which he had last seen upright on his easel, or in the place they were painted for, would now lie prostrate like patients, surrounded by technicians and machinery and bleeding slowly to death under the scalpel and the corrosion of fierce chemicals. The final realisation of the artist's vision, built up touch by touch into a fragile film of paint particles, would here be subjected to the confident probing and unwitting transformations of twentieth-century technology.

Little account would be taken of the more subjective, non-computable factors at play within this microscopic layer of paint: the effects of light and varnish, the optical illusions intended and achieved by the painter, or the inevitable changes, with age, in the balance of tonal values. Our painters might gloomily conclude that, in its attitude to their art, the twentieth century was as domineering towards the past as it was apparently contemptuous of the future.

The Divorce from the Past

The extent of the restoration of painting during the last fifty years is unprecedented, both in quantity and in the extreme methods used, which often range from the injudicious to the plain irresponsible. If we do not restrain ourselves soon, we shall have done to painting what was done to many of the great cathedrals and churches of Europe in the nineteenth century. It was this that provoked Ruskin's great outcry:

Neither by the public nor by those who have the care of public monuments was the true meaning of the word restoration understood. It means the most total destruction a building can suffer . . . the whole finish of the work was in the half inch that is gone, and if you attempt to restore that finish, you do it conjecturally. There was yet in the old some life, some mysterious suggestion of what it had been and what it had lost. Do not let us talk then of restoration; the whole thing is a lie from beginning to end.[1]

Major paintings in major museums have been traumatised by their treatment in a way which is little short of scandalous. The extent of the damage is only now beginning to emerge. Just as we now see, in ever clearer focus, the devastating effects of much short-sighted building development in towns or villages, the confident 'advances' in the expanding field of picture restoration during the last half century are causing many connoisseurs, as well as laymen, to rethink the truisms of a decade or two ago.

Many great masterpieces have been subjected to insensitive, doctrinaire treatment by technicians who may scarcely look beyond the end of their microscope. They seem to be unaware of the implications of what they are doing for the painting as a whole, and their knowledge of its wider historical context is sometimes limited to what might be mentioned in the latest technical journal.

No one would deny the importance of science in the field; but for the workman to be in thrall to his tools indicates a dangerous weakness and immaturity in this, as in any other, discipline. The fact that this attitude, and these excesses, are especially evident in Britain and America perhaps owes something to our general scientific precocity, and even to the Protestant ethic. It may also be a reflection of our weak – or almost non-existent – continuity of craftsmanship, as well as of our position outside the mainstream of the visual arts in Europe. The wisdom of an

[1] Ruskin *The Seven Lamps of Architecture*, Chap VI (London, 1849).

inherited tradition is painfully wanting, as is the sense of trespass which Ruskin talks of: the genuine craftsman's humility before a great work of art.

Ruskin was speaking of nineteenth-century attitudes. Today, aesthetically, we live in a particularly precarious age. In art as in war, the means of preservation are neatly balanced by those of destruction. The new tools that science has provided can either help us to preserve and improve life, or they can damage our inheritance and blight the future. Even where technology is put to good use, its very availability can often be the father of rash action. We have seen some of the tragic results in the excessive, experimental use of modern drugs and medicine, and we are still seeing it in the conservation of works of art.

The danger is especially acute in the field of painting. This is not only because of the delicacy of the art, and the technological revolution. It is also because it is in painting that the twentieth century has produced its most profound disjunction and discontinuity. Our whole notion of what a picture is has been shattered by the advent of abstraction. The continuum of centuries has been broken in content as well as form, the spiritual threads that lead back to the artists who painted pictures of saints, out of piety as well as by profession, have snapped. We still admire their products, and display them in hardboard shrines at well-attended exhibitions. But in art, as in religion, it is easy to confuse churchgoing with godliness.

Our attitudes to such works and to their conservation is closely conditioned by our special view of the past. We are the first generation to believe that we have trapped time, which we see as telescoped into the twentieth century, and to possess what we see as a technology of total recall. It is true that never has so much been available to so many, in reproductions, microfilm and computerised libraries. But there are penalties for this abundance. It gives an illusion of power; the past becomes a mere servant of the present.

Its images and artefacts can be summoned up and dismissed at will. There are of course advantages too: by increasing our historical awareness of the achievements of former ages, we can be inspired to retrieve and preserve them. But our perception of what is worth preserving, and the state in which we choose to preserve it, will again be heavily influenced by twentieth-century priorities and perspectives.

This ambiguity is never far below the surface. We revere antiquity, but we want to reduce it to our own terms. We trap the past, but we tease it in captivity. Our own scientific set of mind, our positivistic certainties and the technological juggernaut on which we career through our own times can easily cramp and crush our sensibilities to the culture of former ages. Our own cultural modes are not designed to sharpen our sensibilities. The music gets louder, and our hearing more resistant. The number of shapes and colours flashing and shrieking before us, importuning our attention, increases steadily in vehemence and intensity, dulling our receptiveness to the more modulated language of great painting.

Could it also be that the very accessibility of our artistic inheritance, of all periods and places, can inhibit as well as stimulate creativity, crushing us by its very weight? (It would be interesting to pursue the theory that 'the more curators, the less creators . . .') Certainly no serious critic would claim that painting is at a peak in the fourth quarter of the twentieth century. The relevance for restoration could be that, in some strange subconscious way, we may be compensating for the shortcomings of the present by over-interference with the artistic excellence of previous eras, through the one means of undoubted modern supremacy – science and technology.

It is even possible to suspect that we somehow resent the very superiority of past schools of painting, and are quietly cutting them down to size, emptying them of some of their

mysteries, and avenging ourselves in the process for obscure dissatisfactions with our current condition. Even if that seems unlikely to be the intention, it is certainly sometimes the result. The same tendency is evident enough in a good deal of our literary and art criticism, which projects backwards our own banal preoccupations and obsessions, deconstructing the past into our glib, binary code of sex and cupidity, Freud and Marx. With such 'interpretative tools', the plays – and even the music – of previous centuries are performed in ways which the authors themselves would not recognise. But even at its most apparently benign, our interest in the past can be damaging: in its modern form scholarly attention can smother its object, the better to master it, by reducing it to a series of exact documentary facts.

The parallel with painting is less obvious at first sight, but it is in the finest of the fine arts that our attitudes are most revealing. Here, too, we 'deconstruct' the works that have come down to us. Today's restorers use modern methods of 'criticism' to flay their surfaces, in the supposition that they are rescuing them from the dim recesses of dark interiors and the heavy curtain of tinted varnishes. Then they triumphantly expose the naked clash of colours to the expectant multitude. This, they claim, is what the artist really meant to say, had he benefited from the advantage of modern insights. As in literary theory, our new critical dogma may soon prove to have been ephemeral and false, mere fashion. But there is a crucial difference: in the case of painting, the damage is permanent.

Museum Life: Sanctuary or Sacrilege?

Another illusion that afflicts the modern mind is the assumption that science, museum culture and a new conservation consciousness have combined to place the

great art of the past in the secure sanctum of a bright, air-conditioned gallery. Indeed, this is frequently seen as one of the indubitable areas of progress in our century. The great majority of art treasures are now in public hands. It is naturally supposed that the state will see to their health, and that the ministrations of a neutral, rational and caring science will be at their disposal for the rest of their days. In this age of 'welfarism', we intuitively imagine that these works will be safer where they can be shielded from the whims of individual owners, and benefit from permanent surveillance: like an aged relative consigned to sheltered accommodation and professional care, they will be 'far better off in a home'.

But it is at least arguable that the excesses or neglect of private collectors can be equalled by the ravages of impersonal committees and institutional life. The private owner is often passionately protective towards his purchases or inheritance; and in the case of paintings in particular, neglect can often prove benign.

Yet the image of museums and galleries as a sort of absolute good in themselves is persistent. They are earnest, educational, democratic establishments: what better resting place for the monuments of the past? But museums do not exist in a timeless vacuum, isolated from the cultural preferences and prejudices of the societies which administer, patronise and finance them. The notion that a picture, after centuries of restless and hazardous wandering, has at last reached a safe haven when it finds itself in a public art gallery is questionable, at the very least.

The gallery itself is likely to be situated in the centre of a crowded, polluted metropolis. To reach it, the picture will have to be moved from its original surroundings where it might have spent centuries of its life – a church or a country house. These transitions themselves can be a damaging experience. Sometimes the painting may have been well cared for and well adjusted to its home. Sometimes it will

have been rescued from a damp, uncertain or insecure existence. But whatever its background or condition, its new environment can present new risks to its inner stability and well-being.

On admission, whatever its state, the painting will be put into the hands of the restorer. It must be made 'fit to be seen' before going on show. This could mean a prolonged spell in the gallery's restoration facilities, whether or not the work is really in need of attention. The treatment may vary in extent or intensity, but treatment there will almost certainly be. Like an alien object, the picture must be absorbed by the gallery and made to conform to pre-established norms and assumptions.

The lucky ones escape with a mere 'surface cleaning'. But most are likely to fall victim to more radical attentions. The unconscious philosophy behind these operations will be simple: the painting must be made as attractive as possible to the twentieth-century mass audience. The gallery employs permanent staff to do this. They are financed by the state, so time and expense are no object. Like school or street cleaners, they clean because they are there to clean, even though the work was done the previous day. The didactic popularism of some state-owned galleries will influence the way the painting is handled in a number of ways. But the overall result will be to bring out its highlights, to clarify, to sharpen – in short to make it more 'acceptable' and more 'photogenic'. The underlying aim will be to attract and startle the public, and to teach it that even old art can be fun. As one article discussing new styles of art criticism recently put it: modern attitudes can prolong a picture's 'glance-life'.[2]

But this is not all. The painting will rarely be allowed to rest in peace, even after the treatment is over. It will be fussed over, reframed, rehung, lent to other galleries in

[2] Dan Gillan, 'New Look at Old Art', *Times Higher Education Supplement*, 20 April 1984.

distant lands, which it will reach by hazardous journeys on aeroplanes, ferries and motorways, and generally lead a busy twentieth-century existence. Each time it is moved it risks more damage, and more damage means further restoration, which necessarily goes beyond the areas immediately affected. The loss of a few flakes of paint, for example, may sometimes occasion a complete relining.

There will be more insidious dangers. The attentions of the scholars themselves immediately after acquisition, though undeniably high-minded, can carry their own risks. There may be some dispute about the authenticity or attribution of a picture, and that in itself will increase the likelihood of an overhaul. The painting may then be cleaned with a new attribution in mind, and this will condition the restorer's approach. If it is thought to be an early example of a particular painter's style, it will unconsciously be made to seem crisper and more naive to conform to that image. If it is assumed to be a mature work, it will be treated accordingly.

Other risks are more remote, but still real. Paintings are frequently pawed or otherwise molested by the thousands that march through public galleries. Well-known pictures are both a target for robbery and a provocation for cranks. To guard against unwelcome attentions of this kind, burglar alarms are sometimes fitted which can come into contact with the canvas and do more damage over time. Important paintings in private hands can be equally unsafe. Their owners may open their houses to the public, which will bring all the dangers of gallery life. And when money needs to be raised under pressure from the tax man, these paintings will be 'done up' for sale. The risks that pictures undergo in the hands of dealers of the less scrupulous type are not peculiar to the twentieth century. But the speed and frequency with which paintings change hands today can obviously compound the dangers. Moreover modern dealers have access to the same technological means of

interfering with canvases as museums do, and some are naturally tempted to use them even more ruthlessly.

The Lost Debate

It has been said that there are two sure ways of destroying a painting: to restore it or not to restore it. Opinions differ on the best way to ruin a picture, or to rescue it. The dilemmas are often genuine. It is therefore strange that there has been so little public discussion about the restoration of painting. The fact that so few dissenting voices have been heard should itself put us on our guard. Such debate as has taken place has been intermittent, inconclusive, or less than fully informed.

In Britain, the accumulation of disquiet over radical cleaning techniques at the National Gallery since the war has overflowed sporadically into the columns of *The Times*. But substantial debate has never got beyond the pages of the *Burlington Magazine*, and it has made little impression on the general public. The main confrontation was between professor Sir Ernst Gombrich then Director of the Warburg Institute, and the technicians of the National Gallery, led by a German painter turned restorer, Helmut Ruhemann. It was Ruhemann's controversial cleaning of major paintings in the National Gallery's collection that provoked concern among experts in Britain and abroad; but this will be described in greater detail in a later chapter.

A more recent outbreak of controversy occurred at the Washington National Gallery in America. The immediate cause was the harsh treatment of Rembrandt's *Landscape with a Mill*, which provoked such disquiet that work stopped in the conservation section of the Gallery for over a year, while an official enquiry took place.

But in general, the technicians remain unchallenged, in Britain and America at least. Radical and questionable

restoration proceeds in the sanitized stillness of many a museum laboratory, undisturbed by critical comment. Even relatively unscathed establishments are now falling into line. Such are the homogenising tendencies of modernity that even countries with more cautious cleaning policies, such as France, Holland, Italy and Russia, could one day succumb.

Why is it that there has been no counter-revolution in this area against the excesses of scientific method? In other fields the doubts have long been growing as part of the general questioning of the assumptions of linear progress which have driven us since the nineteenth century. Nobody any longer believes that fertilizers or social engineering are necessarily good for you, they are simply powerful forces for good or evil. One obvious explanation is that the whole subject of restoration is seen as somewhat rarefied, in which common sense somehow does not apply. It is not always understood, for example, that the paintings that we see today are no longer as they left the artist's hand, but are the result of a succession of interferences, as well as natural changes. Yet, as occasional bouts of indignation which erupt after scandalous examples of over-cleaning show, even the layman sometimes realises that something is wrong.

Another reason for the critical neglect in this field is the traditional secrecy of restorers themselves, whose methods and recipes are rarely exposed to scrutiny. Nowadays, the inquisitive aesthete, or the intelligent observer will be quickly blinded, or at least dazzled, by science, and encouraged to go on his way.

There is a further, more paradoxical explanation, why picture restoration has remained an undisturbed backwater. This is the relative backwardness of the techniques of conservation themselves. It is only comparatively recently that science has been applied to paintings, and the techniques are still in their early, heady days – when

mistakes are most likely to be made. New methods are still being invented, and there is no shortage of restorers who are anxious to put them to the test. The full rigour of the twentieth-century problem-solving approach is now being applied to the painted surface, and to its support.

The answer does not lie in a crude, Luddite reaction. Clearly the technology of restoration is important: we have come a long way since a Frenchman suggested in 1679 that the best treatment for dirty paintings was to 'take warm urine, or simply pee on the painting'.[3] It is not necessarily in less, but in better, more self-critical science that the answer lies, and in more restraint and refinement in its use. And above all, conservation must be illuminated by a sympathetic and informed art-historical view of the painting itself.

The Conflict of Cultures

The signs in antique shops showing a half-cleaned picture suggest that a little professional attention can work miracles, and that a magic solution exists to wash off everything except the 'original', which will re-emerge as good as new. The basic appeal is that of domestic hygiene. But pictures are not plastic surfaces. They are fragile films of cunningly wrought illusion with their own individual integrity. A brisk, housewifely approach is unlikely to preserve this.

One of the main dangers today is the temptation to see it all as a simple matter of mechanics. This was rarely the view in the past, when conflicts and informed controversy around the subject abounded. Even such a figure as Goethe took a serious interest in restoration, and penned an enlightened plea for caution. Painters themselves took a keen interest too, and minded deeply how their own

[3] De la Fontaine, *L'Académie de la Peinture* (Paris, 1679).

pictures and those of earlier artists were treated. Their attitudes are a fascinating and largely neglected aspect of art history. Titian personally retouched some of Mantegna's paintings. Sebastiano del Piombo repaired some of the damage to Raphael's work after the Sack of Rome. Maratta was so upset at being asked to paint over the nudity of a Guido Reni that he did it in distemper to ensure that the pudic veil could be removed later. Delacroix felt so strongly on the subject that he broke off his long standing friendship with the Louvre's chief restorer after a vehement and prolonged public quarrel about conservation styles.

Today it is rare to find those who have an art-historical as well as a scientific education. To the white-coated technician, it is the structure and physical composition of a painting that matters rather than its aesthetic appearance. The myth that science is somehow neutral in its effects dies especially hard in this field. Despite overwhelming evidence, we still fail to realise that anything we do to a work of art we have inherited will be in our own image. So accustomed are we to our own prejudices that we literally cannot see what we are doing.

To understand the importance of the impact of contemporary attitudes we need to look back. Velleities of taste have always been clearly evident in the history of restoration itself. In the last three centuries, one simple fact stands out above all others to prove the point: the eighteenth-century restorers lightened the pictures they worked on, and those of the nineteenth century darkened them. The direct link with the prevailing aesthetic philosophies of the time needs no underlining.

But the best evidence of the evanescence of taste lies in the history of forgeries. Looking back at the extraordinary episode of the 'Vermeers' counterfeited by van Meegeren, it is almost impossible for us to understand how the international experts of the time could have been taken in. It was not because van Meegeren was an incompetent

faker; on the contrary, he devoted enormous care and ingenuity to his task. But, seen from today, his forgeries bear the heavy imprint of their own times, reproducing aspects of Vermeer which appealed to the aesthetic preconceptions of the thirties and forties. Looked at from our vantage point some of the faces bear undeniable similarities to Marlene Dietrich. If any further proof were needed of swings of fashion in art, it is sufficient to add that the *Portrait of a Girl* by Vermeer in the Hague was sold – as a Vermeer – for two florins in Amsterdam in the nineteenth century.

The importance for restorers of these extreme changes in taste is – or should be – self-evident. The practitioners of today cannot fail to be influenced by the same fashions and prejudices that sway the artists of our own generation. We are ready enough to ridicule the habits of the past: the additions and changes introduced into old master paintings by artists or restorers of the eighteenth and nineteenth centuries – a sunset here, animals grazing there, or other fashionable motifs. We refer pityingly to the prurience, prudery and hypocrisy which led the Victorian age to tamper with originals out of concern for their own sexual sensibilities. But we seem less conscious of our own contemporary prejudices, which are broadly those of advertising: impact, rawness and readability. The cultural contagion is almost universal and, in the case of the restorer, insidious. The outlines of figures or objects in a painting by Titian will be tidied up to inch it imperceptibly a few years nearer to our own ideals, still best symbolised by Mondrian's gaunt squares of primary colour. A simple test is to compare the photographic reproduction of a work with the original: beside it, the real Titian can appear wanting in brilliance of hue or firmness of silhouette. An art teacher who once tested his students on this point found that they always preferred the most garish slides to the more faithful.

Old master paintings are obviously the most vulnerable. But the moderns can suffer too. Cubist works are perhaps the most striking case. Their surfaces are now often sodden and monotonous looking: the spiky, provocative interplay of texture – part of the very essence of Cubism – has gone. The contrasts between velvety black recessions, gravelly advancing lights or sudden patches of powdery blue have often gone too, deadened by a combination of wax impregnation from behind, and varnishing in front. The wit and optical tricks of the artist are stifled from both sides, and the work is encouraged to conform to the established idea of a museum painting. Like nanny's rules for respectable clothing on public occasions, the effect of such uniformity is to sacrifice personality to decorum. The surfaces of these paintings were often ruined within the lifetime of the painters themselves. As Marcel Duchamps noted fatalistically: a picture dies after several years, like the man who painted it.[4] After that, it becomes part of the history of art.

Antiquarianism or Scientism?

What are the practical implications for the restorer in the final quarter of the twentieth century? We can never entirely escape our own habitat – and it would be artificial to try too hard to do so. In the last resort, we must be ourselves and use with intelligence and restraint the tools that are available to us. Perhaps the most fundamental rule is the avoidance of romantic extremes, whether in the form of a self-conscious aestheticism, or the romance of science itself, with its continuous drama of new 'discoveries'.

Sentimental antiquarianism – merely another way of imposing our notions on the past – is not the answer. Obscurantism, in the form of the deliberate avoidance of

[4] Pierre Cabanne, *Entretiens avec Marcel Duchamps* (Paris, 1967).

modern methods, is an impractical solution, here as elsewhere. In fact the maximum of knowledge – historical, art-historical and scientific – is essential. We can laugh with Hogarth at the connoisseurs who could only enjoy paintings if the canvases were deeply smoked by time.[5] No one should be in favour of dirt or disfigurement for its own sake. But again it is important to avoid absolutes. Reynolds was also right when he claimed that it was possible to look through the cloud that obscures an old painting.[6] If, as is so often the case, it is advisable not to seek to remove every scrap of earlier varnish, we shall still need this faculty. It is a faculty that will atrophy if we are presented with refurbished, bright, simple surfaces, leaving no room for suggestion or imagination, and reducing pictures to terms that demand nothing of us, and give little in exchange.

All extremes are deplorable, but some are more deplorable than others. The really conclusive argument against a dogmatically radical approach to cleaning pictures is that it has the stark, simple and practical consequence of closing all options for the future, erring on the side of caution does not. The incomparable finish of an old master painting – an intricate fusion of art and time – once gone, is gone for ever.

The final responsibility must rest squarely with the restorer. Definitive and doctrinaire theories must be avoided. The practices systematised and taught at institutes are the antithesis of the individuality of the original creation. What is needed is a balanced and restrained approach, maximum historical self-awareness, a certain humility, and respect for the personality of each painting. In medicine it has become a commonplace since Molière that the remedy can do more damage than the malady. We now also see clearly the advantages of taking account of the whole person and avoiding unbalanced over-treatment of a particular ailment. We also understand that there are some

[5] Hogarth, 'Analysis of Beauty', *Works*, ed. J. Nichols and G. Steevens (1810).
[6] Joshua Reynolds, *Second Discourse to RA* (London, 1769).

problems that are best left untreated, given the inevitable side-effects. The same is true of a work of art: the restorer should think long and hard before touching a painting at all, and should never neglect the possibility of leaving it alone. The ideal is easy to formulate but hard to attain: it is quite simply to avoid the condition of the painting intruding itself upon the attention of the spectator, whether by over- or under-restoration.

In the last resort, there are sound financial reasons for prudence. There can be little doubt that, within a matter of a decade at most, there will be a sharp reversal of contemporary conservation fashions, and the prices of pictures will react accordingly. The values of the art market, made up as they are of a mixture of rarity, snobbery, pride and modishness, as well as of appreciation and connoisseurship, are notoriously volatile. By and large, however, old pictures are increasingly expensive. At their most discriminating, auctions provide an approximation in cash terms of the 'price' of an unrepeatable artistic moment, a peak in the expression of the human spirit. It is not only ethically dubious to doctor, refurbish or simply over-clean old master paintings, it is financially short-sighted too. What would be the re-sale value of a Shang bronze which had been burnished up on a lathe? Who would bid for a twelfth-century psalter in which the previous owner had scribbled modern translations in the margin to clarify the antiquated, over-elaborate illuminated lettering so as to render it instantly comprehensible to the modern eye? As awareness of what is being done to painting increases, the value of relatively untouched work will rise sharply against the spurious products of the laboratory, as buyers come to distinguish more and more between natural ageing and artificial rejuvenation.

One reason why this has not already happened is that the market is often distorted by institutional buyers – state-financed museums and galleries in particular. Some

museum directors are obviously more solicitous than others, and all are theoretically accountable to their trustees or to the state. But they may sometimes lack the protective instinct of the more discerning private owner. They certainly have less incentive to maintain a picture's future market value. Once bought, a painting will almost certainly never be resold. It becomes merely state property, or 'belongs to the collection', and can therefore be experimented with at will, without even the minimal restraints of financial self-interest.

It is amusing to note how, at the other end of the scale, the market works the other way. The *Wall Street Journal* reported a few years ago that American primitive paintings sold better when left in their evocatively unrestored condition, since any cleaning merely highlighted their simplicity.[7] To reach a situation where good paintings were earnestly interfered with, while bad ones were left unscathed, would indeed be richly ironic.

Old paintings are in limited supply. Today we are restoring so much and so radically that we are in danger of undoing, in one fell swoop, everything that many prudent and sensitive collectors and craftsmen have sought over many centuries to preserve, or that chance has spared us. By our selfish zeal, and overweening attitude to the past, we may be depriving our children of the joy of making their own reading of it. One thing is certain: it will not be the same as our own. They, unlike us, will no longer be living under the shadow of the nineteenth century; it is our own excesses that will overshadow them. It is enough to look back a few decades. Already the unreflecting, extrovert character of the 1960s is beginning to seem as dated, and in a sense as forlorn and artificial, as mid-Victorian gloom. In restoration, as in so many other fields, a sense of these simple relativities is the beginning of wisdom.

[7] *Wall Street Journal*, 2 April 1982.

PART I

Chapter One

SUBSTANCE AND SOUL:
The Structure and Techniques of Painting

Is it not strange that sheeps' guts should hale souls out of men's bodies?
Shakespeare, *Much Ado About Nothing*

Before a painting can be restored, it must be understood. Study and reflection are an essential preliminary to action, and sometimes an excellent substitute for it. The more we know of the structure of the painting, the less dogmatic we shall be about modes of conservation, and the more sensible about the limits of the possible or of the desirable.

The pigments used to create the colours, the medium used to carry them, and the techniques used to create an image from these materials are the fabric of the painter's vision. It is impossible to dissociate the artist's pictorial intention from the means he used to achieve it. The

interaction of technique and style may seem merely commonplace. Yet it is too often neglected by art historians and conservators, though rarely by artists themselves. The relationship of glass to Gothic architecture, or of steel and lifts to skyscrapers, is self-evident. In painting the link is just as clear: Turner's exuberantly coloured landscapes and the flamboyant effects of the Impressionists were made possible by the discovery of brilliant chrome yellows and greens, cobalt blues and artificial ultramarine in the early nineteenth century.

For the old masters the bond between means and ends was particularly close. Unlike today, the artist himself was a technician of painting. The difference between the painter's studio now and then is striking. At that time, the colours were normally prepared in the studio itself, either by the artist or his apprentices. Engravings and other illustrations of the period show young boys grinding precious raw materials, such as lapis lazuli, or local earths of Sienna and Umbria, into pigments on huge slabs of porphyry. In the recesses of the studio, other processes – filtering, baking, and distilling – would be going on, as each colour was refined to bring out its own unique potency. Raphael, Leonardo and Michelangelo all served their time at these tasks. In this way artists themselves became the repository of the traditions and craftsmanship of their masters, although they continued to experiment and innovate.

The gradual divorce of the artist from his materials began in the seventeenth century when painters' assistants began to set up shop as independent suppliers of paint. By the nineteenth century the professional 'colourmen' had established large businesses, complete with advertisements, producing not only pigments, but also other artists' materials such as ready-prepared canvases. By the twentieth century the gulf between the painter and his materials was complete. Modern pigments are convenient rather

than 'painterly', leaving a less personal and less sensuous stroke than the hand-prepared oils of the masters. Few artists know or care how their paints are prepared; indeed the larger firms are careful to keep their formulae secret. Painters can also look outside their own small field to commercial paints, produced for everything from cars to spacecraft. New products can bring new stimulation to the artist, but in this case it is rarely based on a logical understanding of their preparation or properties, or on their resistance to ageing.

There has thus been a distinct net loss. Art schools have mostly given up instructing their pupils in technique. In any case, the emphasis has been for so long on 'individual creativity' that even the teachers are now ill-equipped to do so. The apprenticeship system is, of course, dead. Many of the subtler techniques used centuries ago have been lost altogether. Some artists grope to rediscover them, but by and large synthetic mass-manufactured products have taken over.

The importance of all this for restoration is considerable. The danger is that this modern disjunction between the artist and his materials will impair our comprehension, and therefore our ability to conserve the paintings in our guardianship. We no longer have much feeling for the essential wholeness of these works, or for the natural bonds within them. This is one reason why our restorers can calmly leach out the life blood of the paint with desiccating solvents, and coat what remains in anachronistic matt, synthetic varnishes.

The Paint

Over the centuries, artists have used everything from earth to insects to obtain their effects, some of which have proved more durable than others. But at all periods, the paint itself

involves three essential elements: the pigment (e.g. burnt sienna – roasted Siennese earth) to provide the actual colour; a medium in which the pigment is suspended (e.g. oil), which must first be malleable, but then set firm; and finally some sort of diluent (e.g. turpentine) to enable the artist to vary the consistency of the paint.

Most pigments were drawn from the earth or from minerals. But artists were always searching for something new. Paints made from organic substances – resins, dyes, insects, flowers or leaves – produced delicate and subtle hues, but were mostly unreliable or unstable, as impermanent as the flora and fauna from which they came. The Egyptians, Chinese and Romans experimented with chemical colours, but the results were unpredictable. Some of the substances they used were also poisonous, containing arsenic, mercury or lead. When added to cosmetics, as they were in Egyptian times, they must have had a lurid, but also a lethal effect, especially in lipstick.

Throughout the Renaissance and well into the seventeenth century the concoction of colours remained closely connected with alchemy, and thus with the apothecary. Not only cosmetics but medicine and the culinary arts were closely linked with the production of paints. De Mayerne, the great chronicler of seventeenth-century Flemish painting, and a close friend of Rubens and Van Dyck, was a doctor; and St Luke, the 'beloved physician,' was the patron saint of painters.

Until the middle of the eighteenth century the number of really reliable pigments was very restricted – probably no more than twenty. Even these were extremely awkward and demanding to use. The potency of the colour depended upon the size of the grain: glass, sometimes used for blue, turned grey if too finely powdered. Each colour had different properties of density or transparency and each had its problems. Yellows had always been particularly recalcitrant. Deep, dull ochres, made from earths, have

been in use since pre-historic times, but more interesting and vivid hues were less manageable. Some were metals: lead-tin yellow and litharge for example – crisp colours used to highlight brocade in Flemish painting – but difficult to vary in intensity when modelling the folds and shadows of a whole robe. The more flexible yellows were fragile essences of plants or, like Indian yellow, made from the urine of cows. It was only at the beginning of the nineteenth century that the chromes and cadmiums used to such great effect in the sunsets of Turner, and later by the Impressionists, were invented.

Some blues have also caused problems. Ultramarine, made from ground lapis lazuli, is the most precious of all pigments and therefore is often used for the Madonna's robes, generally retaining its brilliance indefinitely. But azurite, another semi-precious stone, could gradually blacken, either because of later penetration by oil or due to ill-advised cleaning with alkalis.

The main drawback with copper resinate, a very commonly used green, was its habit of changing over time into a deep, reddish brown, thus disturbing the whole balance of the painting. Since green was the one colour that could link the cool blues and violets with warmer colours, such as red and brown, the disruption to the delicate inter-relationships of the painting was profound. Such changes can affect our appreciation of a picture considerably. We may see autumnal tints in a landscape where there was once a lively, spring-like green. Not only the aesthetic qualities of a picture, but its very subject can be distorted in this way.

The fact that most colours in most old master paintings have been changing at various rates over the centuries, whilst some, like lapis, have remained the same, means that the whole picture will inevitably look different to the eyes of successive generations. This point is, of course, of fundamental importance to the restorer, and another major argument in favour of prudence and against any drastic

action that might dislocate the balance of the painting still further.

Where fugitive colours have been used side by side in the same picture, the balance intended by the artist is slowly lost over the years. The unity of such pictures can never be entirely recaptured, as the stronger and more durable colours stand out more and more as the others change. It is like a symphony left with only the trumpet and drum parts, and no supporting orchestration. There can be no question of 'getting back to the original' by extensive restoration; the original is quite simply no longer there.

Yet time has its own remedies, and an old varnish can sometimes help to re-establish a new tonal unity by, for example muting the intrusive blues. In the meticulous removal of all traces of yellow varnish, the more ruthless restorer is not solving the problem but merely laying it bare. There are no ideal solutions, although it is always worth recalling that the painter himself would find the naked exposure of blues, dissociated from the surrounding colours with which he had balanced them, intolerable, especially along the connecting line between pigments. Colours can only exist in context, and interact between themselves. Delacroix, who was particularly sensitive to this interaction, once remarked: 'Give me mud and I will make you the skin of Venus out of it, if you will allow me to surround it as I please.'[1] The modern quest for 'historical accuracy' must surely take some account of artists' intentions.

Closer to our own day, at the turn of the nineteenth century, artists were carried away by the newly-exploited rich bitumen which gave a sombre, romantic effect. It had in fact been known for several centuries and was included in *Il Libro del Arte* by Cennino Cennini[2], a medieval

[1] Eugène Delacroix, *Journal* (Paris, 1893).
[2] Cennino Cennini, *Il Libro del Arte*, 2 vols (London 1932, 1933). Cennino was an undistinguished painter but an invaluable chronicler of early Renaissance studio practices.

theoretician, and later became known as Van Dyck-brown. However, the wave of fashion at the end of the eighteenth century for both bitumen itself and the many approximations satisfied a desire for a deep, antique glow – but with disastrous results. It proved as restless as the surface of a Trinidad lake, and erupted in a crocodile pattern of cracks within a few years of application. Many paintings testify to the pitfalls of experimentation and over-rapid commercial exploitation.

In the twentieth century, the main areas of expansion have been in industrial paint-making, rather than in the field of artists' materials. Chemical colours have grown enormously; lakes (natural dyes) and vegetable pigments have almost disappeared, replaced by synthetic vat dyes. Industrial sophistication and specialisation have reached a new peak: a marine anti-barnacle paint now exists which slowly retches out a substance to repel limpets over long periods! There is also a lichen-inducing paint for use in camouflage (which itself incidentally reflects the development of Cubism at the time of the First World War; Picasso once remarked at the sight of a camouflaged tank: 'We invented that'). Heat- and radiation-proof paints invented for the space programme are a special study in themselves, as are those produced for the photographic industry. The amount of research that has gone into the production of a consistent, long-lasting, all-weather khaki paint for army vehicles dwarfs the minute improvements made to the artists' palette. Partly as a result, twentieth-century painters have frequently experimented with industrial products. Already in the 1930s Jackson Pollock was using nitro-cellulose lacquer car paint and industrial enamels.

The Mediums

Pigments need something to swim in. The medium in which paints are suspended inevitably influences their use,

here again the medium is at least part of the message. Turner, when asked what he mixed with his colours, replied: 'Brains!'.[3]

The number of reliable media was found, once more by trial and error, to be restricted. Pre-historic cave painters used grease. The Coptic painters of Egypt used wax, to create a stable, lasting effect. Both animal-skin glues and skimmed milk were known to have been used for some Egyptian wall paintings, as both have continued to be for murals in many countries.

By the end of the fifteenth century, every sort of experiment had been tried: oil and egg, egg and turpentine, honey and egg, wax and egg, casein (skimmed milk) and many aqueous media. Enormous thought and care were given to each material: Cennino Cennini once advised that eggs from town hens were superior as a medium for pigments to those laid in the country since they were of noticeably paler hue! Before the perfection of the use of oil, perhaps the three most successful media were the glue used in medieval manuscript paintings; the egg yolk which bound the pigments of the tempera paintings of the early Renaissance; and pure fresco – water paint on wet lime plaster.

The discovery of oil as an ideal medium was not a sudden phenomenon, but the result of many centuries of frustrating research. Ever since antiquity its tantalisingly attractive properties as a rich, transparent vehicle for pigments had been known. But there were two major drawbacks: getting it to dry, and finding the right diluent to vary its viscosity.

After a process of elimination a small number of oils – walnut, linseed and poppy oil for example – were found to gel and then dry into a film, but only slowly. For the artist, this was a painstaking and laborious business: in Byzantine times oils were prepared by being laid out for months at a time in the sun in great earthenware dishes to thicken and

[3] T. R. Beaufort, *Pictures and How to Clean Them* (New York, 1926).

to bleach, while being frequently stirred to break the gel as it formed. Even when the picture itself was finished the oil had to be dried in the sun, which could lead to accidents, such as the cracking of the panel used for the painting.

The greatest breakthrough came in the early fifteenth century when Van Eyck managed to dry his many-layered oil paintings in the shade. But it was not clear how he had done this, and other artists continued to evolve their own individual practices and recipes. Many resorted to additives to speed the drying of the oil, though some of these could discolour the medium. Centuries after Van Eyck, Titian and Rubens still liked to put their oil paintings in the sun to dry and to bleach the oils, which had yellowed in the shade. There is a famous anecdote in which Titian left his portrait of the Pope on a balcony to dry, where it was seen by pilgrims who mistook it for the original, and knelt before it.

Diluents were equally important, and it is only with the development of turpentine in the fourteenth century that the full potential of oil painting began to be realised. Van Eyck's exquisitely fine films of paint would not have been possible without thinning the oil. Other thinning agents included wine, known to have been employed by Leonardo, a tireless experimenter whose studio was once said to resemble an alchemist's chamber.

Glazes

Glazing was a very personal, almost secret, part of the painter's art, on which the final effect of the picture often depended. Like the vibrato on a violin, it could add a distinctive depth and resonance to an otherwise flat tone. Apprentices were allowed to help with many aspects of the artist's work, but were never involved in the original drawing – the first part of the process – or in glazing – the last.

The exact composition of the mixture was also frequently very personal. Glazes hover between paint and varnish in their consistency, as well as character. Sometimes, when the pigment used is one of the more transparent types – golden ochre for example – and the medium is oil, the glaze is to all intents and purposes a diluted form of paint. At the other extreme, a glaze can be closer to a varnish, such as a minute quantity of lake pigment, perhaps crimson, floating in resin (of which most varnishes are made). The effect of this form of glazing would be to modulate slightly the surface of one area of the painting, like the faintest blush on the cheek of a Venus.

But whether they were added over a similar or complementary colour, glazes could give an exquisitely delicate effect, adding both depth and translucency. Light coloured scumbling (as glazing is called when lighter, more opaque pigments are drawn over dark ones) was frequently used over the shadows of flesh to give the translucent effects of real life – the blueness of blood in veins for instance. The iridescent flesh tones for which Titian – perhaps the most outstanding practitioner of glazing – was so renowned depended upon his mastery of this technique. His incredibly fine evocations are now too often scarred, distorted or simply eliminated by generations of rough treatment, often at the hands of restorers.

In sixteenth-century Venice particularly, the topmost surface of the painting vibrated with infinitely fine glazings, which merged imperceptibly with the varnish, itself sometimes tinted and forming another sort of light, uniform glaze. The cunning optical effects that could be achieved in this way were well understood by connoisseurs. The exact mechanics of the phenomenon were not as yet clear, but artists knew empirically that a thin layer of light-coloured paint over a darker layer produces a bluish glow. They may not have known that this was due to the refractive index of the paint. But they did know that it gave

them an opalescent sky or a silvery, translucent pearl. The Van Eycks in Flanders first realised the possibilities.

After the wonderfully individual achievements of the sixteenth century, glazes tended to become more ritualised and less personal. The practice of glazing the hollows of drapery in the seventeenth century (much of it again now lost) was a rather standardised procedure, though it produced the satisfying richness in the shadow of Lely's satin folds. At its worst, glazing could become a trifle vulgar and cosmetic. The sultry surfaces of mid-nineteenth-century French academic artists, such as Gérôme, helped to discredit the whole layer technique, and to induce the Impressionists to turn to a more direct and less contrived finish to their works.

Yet at its best, glazing often created the last magic film of illusion. The refinement of the technique was matched only by its vulnerability, which has made it a very real challenge to the restorer. The consistency of glazes was often similar to varnish, and the two in practice rapidly became inextricable. Generations of experts have attempted to find a solution to the problem of retaining the glazing, while removing the discoloured varnish. Since the two are as difficult to disentangle optically as they are chemically, the task has been a daunting one. It is also tailor-made to promote disagreement about different priorities and philosophies of restoration – and has not failed to do so.

Varnishes

Only marginally less controversial are the history and use of varnish itself. Its purpose was not only to provide a glossy sheen, or mere veneer to the finished work, but to give the colours depth and saturation, while serving as a protective film against dirt and damp. Varnishes are known to have been used as long ago as Apelles, the Greek painter, although his works have not survived. Descriptions of its

use in his hands are recorded by Pliny, whose famous account of Apelles' intricate optical effects is an early indication of the complexities and uncertainties of this whole field.

Varnishes were sometimes made by melting resins in oils. There were two types of resin: soft, such as mastic or damar and hard, such as amber or copal. All were to some extent coloured – an important factor for the artist and for the restorer – and all tended to yellow with age. Amber, which was particularly prized in the Middle Ages, gave a deep golden glow. Sandarac was a cheaper resin, and produced a dark reddish brown. Both needed to be heated and were rubbed on by hand; remnants can still be seen in the corners of some Byzantine paintings. In more recent centuries the softer resins have become popular, being easier to handle and more easily removed.

As with oil paint, the first problem about varnishes was to speed the drying process. In the search for catalysts, small amounts of lead, orange or yellow litharge, or even calcified bones were added to the mixture. A recipe dating from fourteenth century Strasbourg recommends the heating of oil and red lead with the varnish to achieve a quick drying mixture. But these practices tended to discolour varnishes still further. The vexed question of tinted varnish, and its exact consistency and colour, has been a long-standing source of dispute both for artists and restorers. Today, it is as relevant as ever.

It is obviously vital for anyone engaged in conservation to know how the artists of the time saw their own paintings, even if we are no longer able to recapture the original image. The debate has centred around the impact of antique painters on Renaissance artists, above all of Apelles, the best known. His work was, even then, only known of through the writings of Pliny and other classical authors, but he was reputed to have used dark varnish. Renaissance painters paid close attention to classical com-

mentators. If they interpreted Pliny's report of Apelles' technique to mean that he used a 'tinted' rather than a 'saturating' (enriching) varnish, as he could seem to imply, this would increase the possibility that they themselves deliberately tinted the varnishes they used to finish their own works. The implications for today's running disputes about how far old varnish should be removed are clear.

As interest in glazing and in the finish of the painting grew towards the end of the fifteenth century, so attempts to refine varnishes intensified. The aim was often to produce a thin, transparent lustre, as well as greater depth. Personal variations of tone and texture were, however, undoubtedly a crucial part of the painter's style. Newly-invented diluents helped to give the artist greater flexibility, just as they had done with oil paints. Each artist produced his own formula, but since the varnish on their works has long ago deteriorated or been removed we have no direct way of knowing exactly what each looked like at the time.

What we do know is that painters like Dürer, Leonardo or Titian devoted extraordinary energy, assiduity and sense of nuance to the completion of their works. In 1509 Albrecht Dürer wrote to a client, Jacob Heller:

and when I come over to you, say in one or two or three years' time, the picture must be taken down to see if it has dried out, and then I will varnish it over anew with a special varnish which no one else can make; it will then last another hundred years longer than it would before. But don't let anyone else varnish it. All other varnishes are yellow, and the picture would be ruined for you. And if a thing, on which I have spent more than a year's work, were ruined it would be grief to me. . . .[4]

Titian went all the way back from Venice to Ferrara to readjust the final varnish of his famous *Bacchus and Ariadne* (ironically one of the pictures in the National Gallery in London that suffered from, what seems to the author, over-

[4]W. M. Conway, *Literary Remains of A. Dürer* (Cambridge, 1889).

energetic and insensitive restoration in the late 1960s, and is now coated in synthetic resin[5]). Pope Leo X, who had commissioned a painting from Leonardo, once discovered that the artist was deeply engrossed with experiments on varnishes instead of getting on with the picture. 'Alas, this man will do nothing, for he is thinking of the end before beginning the work', was the Pope's despairing comment.[6]

We shall never again see such paintings as they left the studio, and can only attempt to reconstruct them in our mind's eye from descriptions left by contemporaries. But the lesson for the restorer is again self-evident. Varnishes were never meant as a mere removable screen, but were an organic enrichment of the painted surface itself. Some artists had a habit of making their final touches to a work either within or on top of the varnish, further complicating the challenge to the conservator.

During the nineteenth century many new varnishes were tried, though most were rejected after they had been shown to be dangerous for the painting. The Impressionists broke with the entire tradition, not only of glazing but of varnishes too. They saw their own direct approach as fresher and healthier, relying as it did quite simply on colour and light. In our own day synthetic resins have taken over almost completely, for paintings old and new. As with many modern inventions, the notion that they represent some sort of final solution is highly questionable. Their use on old paintings is rather like accompanying a magnificent meal with Coca-Cola instead of a fine claret.

The great varnish debate interacts closely with other basic elements of painting: the fugitive nature of some pigments or the fragile subjectivity of glazes. The more one probes the history of technique, the more arbitrary some modern attitudes appear. The least that can be said is that, in this hugely complex field, it is wise to tread warily.

[5]*National Gallery Technical Bulletin*, vol. II, 1978.
[6] G. Vasari, *Vita di Lionardo da Vinci* (Florence, 1550).

mentators. If they interpreted Pliny's report of Apelles' technique to mean that he used a 'tinted' rather than a 'saturating' (enriching) varnish, as he could seem to imply, this would increase the possibility that they themselves deliberately tinted the varnishes they used to finish their own works. The implications for today's running disputes about how far old varnish should be removed are clear.

As interest in glazing and in the finish of the painting grew towards the end of the fifteenth century, so attempts to refine varnishes intensified. The aim was often to produce a thin, transparent lustre, as well as greater depth. Personal variations of tone and texture were, however, undoubtedly a crucial part of the painter's style. Newly-invented diluents helped to give the artist greater flexibility, just as they had done with oil paints. Each artist produced his own formula, but since the varnish on their works has long ago deteriorated or been removed we have no direct way of knowing exactly what each looked like at the time.

What we do know is that painters like Dürer, Leonardo or Titian devoted extraordinary energy, assiduity and sense of nuance to the completion of their works. In 1509 Albrecht Dürer wrote to a client, Jacob Heller:

and when I come over to you, say in one or two or three years' time, the picture must be taken down to see if it has dried out, and then I will varnish it over anew with a special varnish which no one else can make; it will then last another hundred years longer than it would before. But don't let anyone else varnish it. All other varnishes are yellow, and the picture would be ruined for you. And if a thing, on which I have spent more than a year's work, were ruined it would be grief to me. . . .[4]

Titian went all the way back from Venice to Ferrara to readjust the final varnish of his famous *Bacchus and Ariadne* (ironically one of the pictures in the National Gallery in London that suffered from, what seems to the author, over-

[4]W. M. Conway, *Literary Remains of A. Dürer* (Cambridge, 1889).

energetic and insensitive restoration in the late 1960s, and is now coated in synthetic resin[5]). Pope Leo X, who had commissioned a painting from Leonardo, once discovered that the artist was deeply engrossed with experiments on varnishes instead of getting on with the picture. 'Alas, this man will do nothing, for he is thinking of the end before beginning the work', was the Pope's despairing comment.[6]

We shall never again see such paintings as they left the studio, and can only attempt to reconstruct them in our mind's eye from descriptions left by contemporaries. But the lesson for the restorer is again self-evident. Varnishes were never meant as a mere removable screen, but were an organic enrichment of the painted surface itself. Some artists had a habit of making their final touches to a work either within or on top of the varnish, further complicating the challenge to the conservator.

During the nineteenth century many new varnishes were tried, though most were rejected after they had been shown to be dangerous for the painting. The Impressionists broke with the entire tradition, not only of glazing but of varnishes too. They saw their own direct approach as fresher and healthier, relying as it did quite simply on colour and light. In our own day synthetic resins have taken over almost completely, for paintings old and new. As with many modern inventions, the notion that they represent some sort of final solution is highly questionable. Their use on old paintings is rather like accompanying a magnificent meal with Coca-Cola instead of a fine claret.

The great varnish debate interacts closely with other basic elements of painting: the fugitive nature of some pigments or the fragile subjectivity of glazes. The more one probes the history of technique, the more arbitrary some modern attitudes appear. The least that can be said is that, in this hugely complex field, it is wise to tread warily.

[5]*National Gallery Technical Bulletin*, vol. II, 1978.
[6] G. Vasari, *Vita di Lionardo da Vinci* (Florence, 1550).

Chapter Two

IMMORTAL ART, MORTAL MATERIALS

Beauty is the marking time, the stationary
vibration, the feigned ecstasy of an arrested
impulse unable to reach its natural end.
 T. E. Hulme, *Speculations*[1]

The artist yearns for permanence, but his materials are all
too mortal. His search for immortality can also conflict with
his equally strong desire for the utmost sophistication of
expression. However discriminating or refined his choice
of techniques or materials, they can never completely
achieve both. Different periods have different priorities,
and this shifting emphasis between durability and finesse
is reflected in the state of the images that have come down

[1] T. E. Hulme, *Speculations: Essays on Humanism and the Philosophy of Art* (London
1924).

41

to us. Essentially, this is the familiar struggle between spirit and matter. The attempt to reconcile the two, to fix a perfect image for ever, runs through the whole history of painting, and illuminates the problems of conservation which we face today. Periods which have stressed the suggestive, the intricate and the elaborate have usually done so at the expense of permanence, and vice versa. The predicament of artists – and now that of the restorer too – emerges clearly from the great peaks in the history of European painting.

Antique Uncertainties

We can only speculate on the form this conflict between the durable and the ephemeral took in antiquity. The very fact that no easel paintings have remained from the period, together with recurrent references in classical writings praising virtuoso realism as well as painterly brilliance, suggests that these qualities, at least at certain moments, must have ranked higher in the priorities of the time than the desire for permanence. There is not enough hard evidence to generalise with any confidence. But both styles involve concentration on the surface of the picture, whether in the painstaking illusionism of realist painting, or the bravura brushstrokes of more impressionistic artists, examples of which survive in murals of the antique period.

We know that astonishing feats of realism were achieved by the painters of Classical Greece. The famous story about the Greek artist Zeuxis makes the point. Birds are said to have come to peck at one of his pictures showing a boy holding some grapes: 'If I had painted the child as well as I did the grapes, the birds would have been afraid of him', the artist is said to have remarked.[2] Evidence of interest in a more suggestive form of painting comes in the anecdote recorded by Pliny of another Greek artist, Protogenes. Having despaired of his attempts to paint a dog foaming at

[2] Pliny the Elder, *Natural History XXXV*, Loeb Classical Library, vol. 9, 1952.

the mouth, Protogenes finally achieved the desired effect by throwing a sponge soaked in paint at the picture. However startling the effect on the connoisseurs of the time, it is unlikely to have proved very lasting.

As usual we are thrown back onto the exiguous evidence of Pliny and Apelles. The fact that Apelles himself seemed more concerned with the mysterious colour-enhancing properties of varnish rather than with its protective powers points in the same direction. However much may have depended on the type of painting in question. The survival of some antique wall painting, in surprisingly good condition – such as that at the Golden House of Nero in Rome – tells a different story. It could suggest that there was rather more concern with permanence in the case of the more decorative arts. Fresco painting, which we presume was unvarnished, was highly developed at the time.

Yet as far as we can reconstruct the progression of painting styles in antiquity, there seems to have been an increasing preoccupation with sophistication at the expense of more lasting qualities. We can only guess, but it seems possible that a moment may have come when the classical artists' striving for excellence may have overridden their sense of the practical.

Medieval Solidity

In the medieval and Renaissance periods, the whole cycle of conflict between solidity of technique and the lure of perfectionism was re-enacted. The structure of medieval paintings, like that of Gothic cathedrals, was imbued with the concept of eternity. We are lucky to have a reliable record of the approach of artists of the medieval and early Renaissance period to their works. Cennino Cennini's *Il Libro del Arte* contains an account of every stage of workmanship in the creation of a medieval altarpiece. He describes the careful choice of panel (poplar in the south,

oak in the north) and the painstaking preparation of the ground. Gesso, a sort of white plaster, smooth ground and mixed with size, or occasionally with white of egg, was painted onto the panel in as many as eight successive layers, the first thick in consistency, and the last finer. Each layer was evened out carefully with glass or metal. When dry, the gesso could be drawn upon freely in charcoal or monochrome. The colours, in tempera, were applied like the gesso itself in layers, and built up in small strokes. Except for the flesh tones, they were scarcely ever mixed. Shadows were achieved not by tonal modelling, but by increasing the intensity of the single colour by a denser mixture, and by multiple coats.

Distrust of mixed colours was based not only on the pragmatic fear that they would not last as well as the unalloyed pigments, but on an almost religious reverence for their intrinsic purity – a reverence increased by the fact that they were often produced by grinding semi-precious stones. Such unadulterated pigments were seen as the only worthy materials for paintings which were to a great extent works of piety; an obvious link between technical and spiritual aspirations towards eternity.

Yet within these rigorous constraints the artist of the time contrived to achieve highly elaborate effects. The sumptuously decorated brocade gowns worn by saints, for example, were simulated with enormous care. Gold leaf was laid on a red ground to give added richness to the almost transparent precious metal. An embossed design might have already been built up beneath in gesso (as in the case of haloes) and the artist might skim one of his most brilliant colours across the burnished gold. Birds or flowers could then be evoked by uncovering the gold again in patterns, which might finally be punched and picked out with further touches of colour. The ritualised discipline evolved by generations of craftsmen, and sustained by the high standards of the guilds, allowed no impulsive individualism or unsound methods.

Medieval painters also had an instinctive mastery of complementary colours: since yellow itself had insufficient intensity, the shadows on a yellow gown were often done in purple to enhance its value. Under flesh painting, green, the complementary colour to pink, was used as a base to give a more resonant depth. However abraded by time and man, or traduced by restoration, these pictures are still monuments of craftsmanship. The success of the medieval artist can be measured in any major museum or gallery today, where our first reaction to these works is astonishment that they should still be there – in their seemingly timeless perfection – at all.

Wall painting achieved a similarly high pitch of perfection and durability in late medieval and early Renaissance times. Only tempera, with its immaculate precision, could rival fresco in lasting power. Provided the wall itself remains intact – and fresco becomes a part of it – it is an almost indestructible medium. A hundred years after its decline at the beginning of the sixteenth century, painters still spoke of it as a pinnacle of technical achievement.

Like most sound materials, both tempera and fresco were inflexible and demanding in use: tempera in its slow, systematised application, and fresco for the restricted time the rapid drying of the plaster allowed the artist to apply his paint. As in the case of tempera this meant that he could not work over the whole surface at once, but only patch by patch, with each day's fresh plaster. Final adjustments could be added later *a secco* (dry). But such additions were known, even at that time, to be ephemeral. The extraordinary accomplishment of Raphael's *School of Athens*, painted in pure fresco, is emphasised by his refusal to have recourse to *secco* for the all-important final touches. It therefore represents a supreme moment of equilibrium between an immensely rich complexity of style on one hand, and a stable, exacting medium on the other.

Unlike easel paintings, frescos are not a film of paint on a surface, but impregnate their own support, and need no varnish. Given an intact, dry wall, they are spared many of the rigours of restoration, except for the removal of dust and dirt. As the recent cleaning of Raphael's *Galatea* in the Farnesina in Rome has shown, and as the present work on Michelangelo's Sistine Chapel seems to confirm, this is one area where impressive results can be had with far less risk.

Meanwhile, in the north, a new perfection had also been reached in a new material: oil paint. The unique achievement of the Van Eyck brothers was to combine the best of the old and new skills in stable fusion. As manuscript and stained-glass painters, they inherited the aspirations towards timelessness of the monastic medieval tradition. Their genius was to incorporate this tradition in the more mobile medium of oil. When one of the most exquisite examples of the new oil technique – the Portinari Altarpiece by Hugo van der Goes – arrived in Florence in 1471, the impact on the Italians of the brilliantly smooth and luminous glazed surface was immediate and profound. It was already a period of intense excitement and feverish investigation in Italy itself, and the artists of the early Renaissance were exploring innumerable new avenues of expression. Currents of innovation were moving alarmingly swiftly, often accompanied by passionate feelings. Vasari even has a (probably apocryphal) story about the Florentine painter Castagno murdering Domenico Veneziano, a noted researcher into different media, to gain a monopoly in the secrets of oil painting.

The Paradox of Perfection

In retrospect, it is clear that the moments of exquisite balance achieved by Van Eyck in oil and Raphael in fresco could not last indefinitely. It is true that the Northerners maintained

their conservative traditions for a century and a half after Van Eyck. But the more exuberant spirit of the Italian Renaissance burst through the tight technical bonds restricting the artist. In the restless experimentation of the last decades of the fifteenth century, the seeds of a new instability between the inspiration and individual genius of the painter and the constraints of his materials were already present. Northern artists too were eventually to be overwhelmed in the wave of innovation.

Even before paintings from Northern Europe like Hans Memling's immaculate portraits arrived in Venice, Giovanni Bellini was investigating ways to convey in paint a more subjective and expressive idea of the human personality, and to express moods through landscape. For this the artist needed more fluid and less uncompromising processes than tempera painting, with its admirable clarity and taut, hard definition of line and modelling, would allow. It was in Bellini's studio that the smooth glazing that had been so much admired in Flemish painters was developed in new and more adventurous directions. What in the North became the cul-de-sac of increasingly minute and anecdotal detail, in the work of the Antwerp mannerists for example, was used in the South for more suggestive and imaginative purposes. It was in the circle of Bellini that the vastly more expressive – but also more fragile – painting of the Venetian High Renaissance was born: Giorgione, Titian, Sebastiano del Piombo, Lotto and many others were deeply influenced by Bellini. The first steps away from the priorities of permanence, and towards a freer but more transitory style, had been taken.

Leonardo, the great experimenter, visited Venice in the middle of this seminal period. As an artist and thinker he was only too conscious of the conflicting demands of longevity and subtlety. He once even recommended sticking glass to the face of paintings with varnish, or firing the painted surface, like enamel, to preserve the image inde-

finitely. In fact he never pursued such extreme expedients, but he pioneered instead many of the new, less stable, techniques which were superimposed on the more solid craftsmanship of the fifteenth century.

In an attempt to escape from the rigid confines of fresco, Leonardo is said to have resorted to an experimental mixture of oil and varnish to paint his great *Last Supper* on the wall of the monks' refectory at Santa Maria delle Grazie in Milan. The results were disastrous.[3] The artist had wanted to give full scope to his own versatility, to be able to add a touch here and there as the inspiration took him. An eye-witness, the novelist Bandello, left a vivid description of Leonardo's impetuousness as a painter:

> Many a time I have seen Leonardo go early in the morning to work on the platform before the Last Supper; and there he would stay from sunrise till darkness, never laying down the brush, but continuing to paint without eating or drinking. Then three or four days would pass without his touching the work, yet each day he would spend several hours examining it and criticising the figures to himself. I have also seen him, when the fancy took him, leave the Corte Vecchia when he was at work on the stupendous horse of clay, and go straight to the Grazie. There, climbing on the platform, he would take a brush and give a few touches to one of the figures: and then suddenly he would leave and go elsewhere.

But his materials could not live up to the master's own aspirations. Within a few decades of Leonardo's death, his great mural was scarcely visible. It happens to have been painted on a particularly porous wall, and much of the unassimilated oil paint flaked away from the plaster, leaving only the traces which are being restored for the nth time today. The ghostly remains of this magnificent

[3] His last, lost, wall painting of the Battle of Anghiari for the Palazzo Vecchio in Florence was carried out, apparently equally unsuccessfully, in encaustic following a classical technique described by Pliny.

masterpiece can still be read, though with tragic irony, as an example of Leonardo's preference for suggestion over precise definition. Leonardo's most influential achievement, the tonal painting system of chiaroscuro, depended on a thousand minute modulations of light, colour and graduated shading. Fortunately he left a vast quantity of drawings and studies which enable us to reconstruct his own vision of his paintings, which have mostly come down to us with much of their finesse diminished. Profound research into anatomy, comparative proportions, light and shade on geometrical forms, perspective and movement, and much else, went into the numerous preparatory drawings he made simply to capture the effects of light on a baby's face. But the illusions he conjured up were too complex and delicate to withstand the random, indiscriminate effects of the passage of time.

The impact of the Mona Lisa at the time was clearly extraordinarily vivid even at second hand. Vasari, who never in fact saw the painting himself, left a tantalising description of the picture in its first youth, presumably based on detailed accounts, perhaps from Andrea del Sarto and others:

> the eyes possess that moist lustre which is constantly seen in life, and about them are those livid reds and hair which cannot be rendered without the utmost delicacy. The lids could not be more natural, for the way in which the hairs issue from the skin, here thick and there scanty, and following the pores of the skin. The nose possesses the fine delicate reddish apertures seen in life. The opening of the mouth, with its red ends, and the scarlet cheeks seem not colour but living flesh. To look closely at her throat you might imagine that the pulse was beating.[4]

One of the few areas of innovation Leonardo did not initiate was the use of impasto. Venetian painters of the time were quick to see the sensual and dramatic potential of an impastoed surface, in which the personality of the artist could be embedded in every stroke. The possibilities were

[4] G. Vasari, *Vita di Lionardo da Vinci* (Florence, 1550).

limitless: three-dimensional effects, more prominent high-lights, and a flickering diversity of textures. The virtues of impasto were most richly realised by Titian. Palma il Giovane, a fellow artist who knew him well at the end of his life and completed Titian's *Pietà*, said of him:

> Titian based his pictures on a mass of colour. . . . The first pencilling with a full brush and thick heavy colour, the half tones in pure red earth, the lights with white, then broken with the same brush with red, black and yellow. In this manner there were four pencillings for a whole figure. Between the pencillings more or less time would elapse. It was contrary to his habit to finish a painting consecutively, because as he said, 'a poet who improvises cannot hope to make metrical verses'. The contours and modelling would often only be fixed with the third or fourth pencilling. Then began the thin glazing and semi-glazing and finishing. In finishing Titian painted as much with his fingers as with his brushes.[5]

Titian's use of glazes gave maximum luminosity to his impastoed paint, and had the resonance of light on the surface of a choppy sea. The rapid spread of the impasto technique in Venice, together with the use of dark-coloured grounds and idiosyncratic brushwork meant that, in terms of durability, each artist was increasingly making his own terms with the future. Not surprisingly perhaps at the time, the obvious longer-term risks of raised paint were out-weighed by its more immediate attractions.

As in fresco, so in oil, Raphael found a golden mean. He used Leonardo's chiaroscuro methods – building up his modelling in tone and not just in colour – but incorporated them into the more conservative painting structures he had learnt in Perugino's studio, so combining the medieval principle of enhancing the intrinsic value of each colour with Leonardesque tonal unity. All this produced an image of enamelled permanence which has withstood the test of time far better than Leonardo's own work.

[5] Marco Boschini, *Le Ricche Minere della Pittura Veneziana* (Venice, 1674).

The Temptation to Excess

But most painters of the time were intoxicated by the unprecedented possibilities of oil, and it was here that the effervescence of the Renaissance had its most dramatic consequences for the structure and solidity of later painting. Individualism was at a premium and the new medium gave maximum scope for self-expression. Whether in the infinite ingenuity of Leonardo's glazing, especially in his later paintings (now darkened beyond recognition), or in the impastoed handwriting of the later Venetians, like Tintoretto, oil painting was swept away by its own potential. It was also in this period that canvas, whose irregular texture was itself a new attraction, came into its own. Huge areas could be covered quickly by picking out highlights and a few brilliant details on a dark ground, a speciality of Tintoretto. These scintillating strokes were, however, precariously supported against a background of half-tones and shadows. Within a century these 'semi-conductors' had become so transparent that often only the brown ground, which thrust its way steadily forward, was still visible.

In his enormously successful career Caravaggio personified the triumph of evanescent theatricality over more lasting techniques. The hallmark of his style – light brushwork over a sombre ground, like so many fleeting, luminous footprints – reminds us inescapably of his own personal circumstances: a hot tempered man, he once found himself on the run from the police after he had killed a waiter who had brought him the wrong artichokes. The powerfully dramatic light effects he achieved, together with the provocative treatment of his subject matter, caught the imagination of the whole of Europe. His methods influenced a whole generation from Velazquez to Rembrandt, Vermeer and Georges de la Tour. These great masters all evolved their own, relatively stable versions of

his dark ground technique. But in the work of many lesser artists, the impact of Caravaggio led to easy but ephemeral effects.

Misgivings about the construction of such paintings soon surfaced. Already towards the end of the seventeenth century, the extremely vivid, even violent, colouring of many Italian works may have been in part a reaction to the perception of the darkening oil painting of the previous generation. Guido Reni's late lilac-coloured flesh paint is said to have been a conscious effort to counteract the combined result of increasing transparency of the paint, and sombre, ageing varnish. Carlo Cesare Malvasia, writing towards the end of the seventeenth century, said of Reni: 'Undoubtedly one can see his prophecies borne out, that whereas the paintings of others lose so much with time, his own gain with the yellowing of their pallor and the acquisition of a certain patina that moderates their colour to a true and good naturalism. The works of others darken too much, not leaving any distinction between more or less obscure parts, or half tones or highlights.'[6] Scanelli, an Italian connoisseur and writer, who had met Reni himself, doubts this explanation.[7] But his reluctance to believe that artists would sacrifice the present to the future in this way may well underestimate Reni's very real concern for the after-life of his works.

Northern artists lived less dangerously. Even with the advent of oil, they stayed closer than the Italians to their medieval traditions, continuing, to use carefully prepared panels well into the seventeenth century, and maintaining the Van Eycks' emphasis on the thin, diluted application of oils. In contrast to the Italian preference for the corrugated texture of impasted paint on canvas, they tended to use oil to extend into the sixteenth and early seventeenth centuries the smooth rich style of the early Flemish panel painters.

However, in either approach, the colour of the ground, far

[6] Carlo Cesare Malvasia, *Felsina Pittrice* vol. II (Bologna, 1678).
[7] Francesco Scanelli, *Il Microcosmo della Pittura* (Cesena, 1657).

from being the routine preparatory measure it might seem, was a crucial element in the composition of the work as a whole. Like a musical key, it set the tone and determined the range and character of the colours that were to be superimposed on it. Unlike Italians, most Flemish and Dutch painters continued to use light grounds until late in the seventeenth century. Their luminosity not only gave greater permanency to the image, but allowed more flexibility – in the use of thin half-tones, for example – and greater legibility of detail.

Thus, in north and south similar materials were used in radically different ways. For the Italians, what mattered was the generalised depiction of form enlivened by a painterly surface. Further north, interest in the naturalistic and the particular predominated. Oil could adapt to either. Bosch and Brueghel epitomised the virtuosity of the northern descriptive method. Both used very finely diluted oil paint on a clean, stable surface to produce their rapid, surely drawn figures in a technique almost analogous to that of pen and wash. Yet, paradoxically, their paint was less vulnerable than that of the more lavish, and often brittle brushwork of contemporary Italians, with its tendency to crack and to sink back into its dark base. As a result, the delicate hues on Bosch's freakish figures are still almost as crisp and incongruously exquisite as when they were painted over four hundred years ago.

But the Northerners sometimes went to extremes too, carried away by the sophistication of their own virtuosity. The incredibly fine sepia glazes of Van Goyen, like overdone Caravaggesque contrast, reach a point of excruciating fragility. The combination of a microscopic film of semi-transparent oil, drawn over a practically invisible ground, which scarcely disguises the thin oak panel, delights the eye but can endanger the image. With the growing translucency of the paint the grain of the wood itself begins to obtrude – like the ground of an Italian

painting – especially if encouraged by heavy-handed cleaning.

Rubens – a sort of Flemish southerner of the North, who had spent his youth in Italy – synthesised both techniques in his superbly light yet vigorous use of oil, developing all the optical possibilities of northern glazing, while exploiting the more vivid attractions of Italian brushwork. In the turbulent strokes of his *Château de Steen* landscape in the National Gallery in London, intimately described details are still recognisable to the last leaf three hundred years later.

Rembrandt evolved his own idiosyncratic approach and fits into no ready pattern. His earlier work, when he was still a fashionable society painter, had an ingratiatingly smooth, licked finish, reflecting his training with a painter on metal, Peter Lastman. But after his bankruptcy, when he became something of a recluse, he evolved a highly individual style more calculated to satisfy his own needs than those of his customers.

The first impact of a Rembrandt painting is usually of a figure illuminated against a dark backgroud, and he was indeed – like so many other painters of the period – influenced by Caravaggio. But unlike the Italian's other followers, who used the dark background itself as a middle tone in their work and painted in broad brush-strokes directly upon it, Rembrandt based the construction of his works on the northern practice of layer painting. The main difference was that his layers were often of thick paint, applied with firm, bristle brushes. He relished the glutinous surface effects of oil itself, to the point where his work was criticised as 'uncivilised' because of an impasto which could be 'picked up by the nose'. His reply: 'I'm no dyer, but a painter' – reflected his view that oils should be used to their full, coagulating potential and were inherently distinct from the flat insubstantiality of dyes. In fact he is thought to have sought to bolster the

richness of his oil still further by adding mastic resin and using thick, Venice turpentine and ground-glass filler in his paints. This helped to give his works an interesting luminosity and a slightly granular texture, though he was careful to control the proportions of the mixture to avoid any wrinkles or contractions in the raised surface. This very personal technique was ideally suited to Rembrandt's search for a peculiarly suggestive realism, although at the time the roughness of the surface earned him criticism for lack of finish. This provoked his crushing response: 'A picture is completed when an artist has realised his intentions.'

Rembrandt's individualism was thoroughgoing. Beginning with a thin layer of grey over a red and ochre ground, he built up a distinctive visual play between warm and cool colours and thin and thick layers, using an extraordinary alternating sandwich of each, especially in his later work. It is by such techniques that he evolved the opalescent vibrations and the introspective depths of some of his late self-portraits. Those who claim that the skinned, flat look of so many Rembrandts in some major collections, with their sharp transitions and angular modelling, is what the artist wanted, should compare these harshly edited paintings with the subtle calibrations from light into velvety darkness of his prints of the same period.

But despite the variations of individual genius, by the end of the seventeenth century, the dark, dramatic Caravaggesque mode had swept the whole of Europe. Even Dutch landscape painters had started to use canvas and sombre grounds. Spaniards, many painting in Naples soon after Caravaggio, were irresistibly attracted by its expressive force. The striking, but now sadly sunken portraits of beggars by Ribera illustrate both the potential and the dangers of the method. The risks were becoming more evident every day to artists themselves. Pacheco, Velazquez' father-in-law, advised painters to 'paint lighter

than you think because time will darken it.'[8] After an initial Caraveggesque phase in Naples, Velazquez himself began to paint on a cool, grey priming, more in keeping with his own temperament. Indeed some of his pigments included a quantity of marble dust which helped to give his brushwork a particular texture and a certain solemn, translucent glow.

The Rational Reaction

The growing disenchantment with dark-toned painting was reflected in a new interest in Veronese, who had worked on an opaque grey-green background, and who had replaced Tintoretto as an influence on younger artists. Correggio and Barocci, both Renaissance painters who had used light grey or pink grounds, also came back into fashion at the beginning of the eighteenth century. The reaction against exaggerated baroque contrasts was part of a general reassessment of techniques, which can be seen as an aspect of eighteenth-century rationalism. The implications of the Enlightenment for painting are almost too obvious to need mentioning. Canaletto started working on brilliant blue grounds, others used pink. Hogarth and Boucher drew on the brightly-lit world of the theatre, and the creamy brilliance of the latter's brushwork was as immaculate as Sèvres porcelain.

In England, Gainsborough used oils with the freedom of watercolour. Working in a darkened studio with diluted washes of oil paint and very long-handled brushes, he gradually allowed more and more light into the studio as the painting neared completion, so that his final, bright touches drew the work together in a clear focus. The somewhat ethereal tonalities of much eighteenth-century

[8] Francisco Pacheco, *Arte de la pintura, su antigüedad y grandezas* (Seville, 1649).

painting might lead one to suppose that it was less than sound in construction. It might seem self-evident that a sketchy Gainsborough or a rococo Fragonard must have less staying power than a robust work by, say, Poussin. In fact this was not so, for a number of reasons. One was a growing consciousness, as the century wore on, of the increasingly visible penalties sixteenth- and seventeenth-century Italian painters and their followers had paid for their dramatic effects (an awareness which had the incidental effect of provoking a new interest in the cleaning of old paintings).

The lessons for artists were clear, and the eighteenth-century drew characteristically rational conclusions. The scientific approach of the times encouraged a strong determination to develop more stable painting techniques. The rise of the public museums – a new concept at the time – brought with it a new conservation consciousness as well, which in turn inspired research into the longevity of works of art. The simple act of hanging pictures in chronological order helped artists of the day to gauge the resistance of different techniques. It would be odd if they had not seen the implications for their own works. Oudry advised against strong colour for priming and suggested a middle tone, because 'a tone always asserts itself'. He condemned, above all, 'reddish brown grounds, which have reigned over all, producing very bad effects; shadows laid over them inevitably hardened into a monotonous similarity, and the most precious half tones faded and came to nothing'.[9]

Oil painting itself was never seriously in question despite the technical deficiencies of previous centuries. The eighteenth century could see from Rubens that, used in a light, painterly way, the brilliance of oils would remain unim-

[9] J.-B. Oudry, 'Discours sur la pratique de la peinture et ses procédés principaux: étendre, peindre à fond et retoucher'. Published by E. Piot in *Le Cabinet de l'Amateur* (Paris, 1861–62).

paired by the passage of time. Fragonard was not alone in finding inspiration in Rubens' dazzling, but safe, methods and based his early style on them, with superb success. Artists were learning to be cautious in their use of varnish. Some theoreticians, such as the French eighteenth-century artist Liotard, considered that most of the problems of oil painting were connected with varnish, and urged artists to be as sparing as possible in its use.

It is notable that, though well aware of its pitfalls, eighteenth-century painters did not discard varnish completely as the Impressionists were to do later, but allowed themselves a guilty flirtation with it, while keeping within the bounds of prudence.

Although continuing with oils and varnish, artists also experimented with new media which dispensed with both. The use of pastel and watercolour, partly inspired by the fresh powdery look of the Roman frescos at Herculaneum, spread rapidly throughout Europe from France in the middle of the century. The survival of the Herculaneum paintings was itself a demonstration that light-toned works were by no means necessarily ephemeral, and we know that connoisseurs of the time certainly did not think in those terms. The Comte de Caylus, a central figure at the time, wrote:

it is certain that oil has lost us a great deal from the point of view of conservation. That is not all; it alters pigments and yellows them in contact with the air. Colours often change unevenly, and the shadows blacken. Our paint flakes, whereas antique paintings appear to me to have avoided all these problems.[10]

Provided that pastels and water-based paintings are kept in safe conditions – which means behind glass and out of the sunlight – they could retain their fresh charm almost indefinitely. They needed no varnish because the

[10] Comte de Caylus, *Réflexions sur quelques chapitres du XXXVème livre de Pline* (1752).

luminosity of the paint came from the white paper ground itself. It is therefore ironic that it was only when the Herculaneum frescoes were subjected to ill-considered restoration in the nineteenth century, involving the application of dark varnishes, that their light texture was ruined.

Individual artists of the eighteenth century were often impressive technicians. Canaletto used the scientific advances of his time to realise an almost machine-like precision in his images. The newly invented camera obscura enabled him to place the minutely observed detail of his views of Venice in a mosaic of interlocking tonal relationships. This sureness of tone went hand in hand with soundness of structure. Different levels of the image were built up in a series of carefully computed oil glazes, which combined to produce a startling lucidity. First the colour of the sea with all the horizontal gradations of recession would be applied on to a rich blue ground; then perhaps the exquisitely defined vertical reflection of a nearby palace; and finally the lilt and gleam of the waves themselves. The splendid condition of much of Canaletto's painting today, and notably the superb collection of his works at Woburn Abbey, bought directly from the artist, is a testimony to the clear intellect as well as the tireless craftsmanship of the artist.

The subject-matter of the revolutionary painter David, who worked at the end of the century, could hardly be in greater contrast. Constable called the *Sabine Women*, painted in 1799, 'a stern and heartless picture'. It is indeed a long way from the delicately refined products of Boucher and Canaletto. David himself despised what he called 'powdered doll painters',[11] whom he accused of capturing the eyes of women through theatrical poses, false complexions and colourful clothes. Yet technically he was himself still very much a child of the eighteenth century, and had in

[11] The phrase has also been attributed to Goethe.

fact taken his first lessons with Boucher. He used white and ochre as a base, which shine through the thin transitions of his colours, harking back once more to the watercolour techniques of antiquity.

Inevitably the overpowering influence of the French Revolution had its repercussions on his style, and his materials. 'The Robespierre of the brush', as David was called, stabbed at the canvas with short scratchy brushes, the results being vividly apparent in the hatched background to his *Marat in the Bath*. The unabashed sketchiness his methods produced stemmed in part from disdain for convention, and reflected the passions and politics of the time. His pure earth colours were used with spartan simplicity, but Delacroix's (only half serious) observation on this limited range – 'dust thou art, and to dust thou shalt return' – has not been borne out by time, which has treated David's work more kindly than that of Delacroix himself. The revolutionary artist's direct and sparing use of paint proved to have the staying power as well as the force of simplicity, and led on to the whole new technical era of the Impressionists.

But the eighteenth-century artist was not infallible. Watteau and Reynolds were great artists, but sometimes flawed technicians. Watteau's feverish way of working reflected an unhealthy constitution; as a consumptive who died early, he felt time pressing hard on his heels. His effects were sometimes fragile, transitory and highly vulnerable to over-restoration. To enrich the surface of a canvas he had a habit of reviving the previous day's work by applying a coat of pure oil, in which he attempted to fix his vision by floating his colours and forms onto it in a series of feathery strokes and brilliant touches. He also tended to use unorthodox mixtures of colours such as ultramarine and verdigris for his skies – pigments which normally act against each other, although by using more than the usual amount of oil he seems to have managed to maintain a

tenuous balance. Visitors to his studio were often scandal-
ised by his haphazard way of working, remarking that he
scarcely bothered to clean his palette.[12]

Of the major eighteenth-century painters, Reynolds
used some of the most dubious methods. This was despite
– or perhaps because of – his intense interest in technical
matters. His notebooks reveal how concerned he was about
the structure of his paintings, and his search for a technique
that might emulate the effects achieved by the old masters.
Reynolds constantly thought that he had, at last, hit on the
right recipe. In 1770 he wrote:

> I am settled in my manner of painting; first and second either
> with oil or copaiba [a balsam resin], the colours only black, ultra-
> marine and white, second the same, last with yellow ochre and
> lake and black and ultra-marine, without white, retouched with a
> little white and other colours.

Benjamin Haydon, an unsuccessful fellow painter, who
wrote a poignant but perceptive autobiography before
committing suicide, has left us a shrewd diagnosis of
Reynolds' failings:

> Reynolds was always pursuing a surface – was willing to get at
> once what the old masters did with the simplest materials, and
> left time and drying to enamel. That enamelled look, the result of
> thorough drying hard and time, must not be attempted at once. It
> can only be done as Reynolds did it by artificial mixtures, which
> the old masters never thought of, and therefore the greatest part
> of Reynolds' works are split to pieces from their inconsistent
> unions. To wax a head, then egg a head, then paint in oil on these
> two contracting substances, then varnish, then wax, oil, then
> paint again, all and each still half dry beneath, could end only in
> ruin, however exquisite at the time.[13]

Just as Reynolds attempted to recreate the appearance of
the great schools without mastering their basic disciplines,

[12] Comte de Caylus, *Vie de Watteau* (Paris, 1748).
[13] B. Haydon, *Autobiography* (London, 1841).

so his attitude to materials sprang from an outer, rather than an inner, understanding. By the later eighteenth century, these materials were already moving into the hands of the professional colourman and out of the hands of the artist. Reynolds is a perfect example of the dangers of a painter losing touch with his tools. A great theoretician but an impractical craftsman, he himself once commented wryly of his own painting that it 'came off with flying colours'.

He was right to worry about the permanence of his work. The present corpse-like pallor of many of his portraits results from his frequent use of a fugitive red lake tint from India, and rose madder, a notoriously ephemeral pigment which quickly drained from the once-pink cheeks of his sitters. His penchant for adding new layers of paint on top of varnish did not help. He also indulged in rich brown bitumen for his backgrounds, in a romantic effect to recapture an instant, old master atmosphere. Today we are sometimes left with a gruesome combination of pallid faces and tarry, heavily crackled surroundings – a grim reminder of the importance of stable techniques. Needless to say, such pictures are an almost hopeless challenge to the restorer.

Seen as a whole however, the eighteenth century was a period of reasoned balance between the requirements of permanence and painterliness. The exquisitely unified, mature tones of Chardin's *Boy with a Top*, and the intact and exuberant frescoes of Tiepolo, are there to prove it.

New Uncertainties

Inevitably, in the restless world of art and artists, this equilibrium was not long maintained, any more than it had been at the time of Raphael or Van Eyck. The Romantics who followed led to new uncertainties in painting, as in

politics. For them, permanence was by no means the overriding priority. What they wanted was dramatic visual impact, and they too often relied on contrived effects to get it.

Technical and individual adventurism abounded, and as usual some innovations proved longer-lived than others. Delacroix once even experimented with powdered, mummified bodies. As a ground for a painting, this produced a deep, rich brown base of extremely mortal frailty. Turner, in a similar search for colouristic impact, built up some of his paintings with bitumen and a mass of minute touches of pure oil colours, finishing with water-colour highlights in Chinese White.

It was a period of enormous intellectual and artistic confusion, in which starkly opposed schools of painting existed side by side. The sobriety of the neo-classical Ingres, who once said that engravings were more significant than paintings because we can see the forms in them more clearly, predictably led in general to less problematic pictures for posterity. But his less rigorous followers tended to cultivate a nostalgia for the past, which often led to a reversion to dark painting, elaborate glazing, and sometimes even tinted varnishes. Books on 'the secrets of old masters' – as though discussing a lost civilisation – were published at this time. By mid-century, all this led to a full scale academic art, much of which is still to be found in the reserve collections of European galleries.

Technically, much of the first half of the nineteenth century was a paradoxical and even incoherent age, during which painters finally lost contact with many of their own best traditions, and were encouraged by scientific speculation to grope for the experimental and exotic. Much old ground was retrodden in the process. In his diary, Delacroix discusses the possible use of olive oil, even though the craftsmen of the fifteenth and sixteenth

centuries had already eliminated it from their list of practical painting media, for the excellent reason that it simply would not dry.

The break in the chain of tradition was epitomised by the advent, at the beginning of the nineteenth century, of ready prepared machine-smoothed oil-grounded canvases. The convenience is obvious, but the drawbacks were soon equally evident. Excessive amounts of brittle glue used in their manufacture produce the exaggerated crackle characteristic of much nineteenth century painting. This gave another spin to a vicious circle which was hastening the demise of academicism. The flat, glossy finish of the academic school was enhanced by such standardised materials, which in the event often proved unsound. A new search developed for more simple, true and unaffected methods which could be used to paint directly from life.

The Permanence of Impressionism

Impressionism was heralded by artists as different as David, Turner and Delacroix. After the extravagances and artificialities of half a century, artists were coming back to fundamentals. Stylistically, Impressionism represented a deliberate affront to the artistic conventions of the time. But there is no doubt that, technically speaking, this rethinking of painting methods was a healthy and long-overdue development.

It would be wrong to confuse the Impressionists' lightness of tone with an insubstantial technique – as the eighteenth century had shown. Their main aim was to get away from all the virtuoso contrivances of the Romantics, and the ultra-smooth glazing of the academics. Their new deliberately awkward, artless style first broke upon the world after the Salon des Refusés in 1863. Ever since, their exhibitions have been discussed as artistic 'happenings'.

But it is important to remember that the achievements of the Impressionists were based upon sound workmanlike principles of painting, and a new emphasis on craftsmanship. These revolutionaries worked on their own without the superstructure of the big studios of the early nineteenth century, and were again more personally involved in the whole process of painting. The image of the Impressionist going out alone into nature, with his palette, colours and canvas on his back, reflects an essential truth about a new naturalism towards both his materials and his subject. This simplicity was not unreflective. It represented a deliberate attempt to dispense with artificial barriers of dark grounds, glazes and varnish and to confront the spectator with the raw reality of the painter's vision through brushwork and paint alone. No glossy or subtly manipulative films were to disturb the triangular relationship between the artist, reality and the public.

The Impressionists were revolutionaries indeed, yet they wanted their works to endure. Fortunately, by comparison with the splendid fragility of the Caravaggesques, there was quite simply less to go wrong. Their feelings were best summed up by a Post-Impressionist, Bonnard, who said: 'I hope that my painting will hold, without cracks. I would like to appear before the young painters of the year 2000 with the wings of a butterfly.'[14]

None of the three functions of varnish seemed essential to the Impressionists. They actively rejected a glossy finish, and saw the protective function as outweighed by the innumerable problems of discoloration and restoration which varnishing had always entailed. Depth of colour was no longer an overriding prerequisite either; their works depended more on brightness than saturation. This brightness was achieved by using the contrast of colours and the reflected light of a white ground, in the same way that the

[14] P. Bonnard, *Notes* (1946). Published by A. Terrasse in the catalogue to the Bonnard Exhibition, Centre Pompidou, Paris, 1983.

pastel painters had done in the past. In fact many artists of the period, from Millet to Degas, operated on the border between paint and pastel. They also benefited from the striking new pigments that science had for some time been providing. Already in 1824, the French government had held a competition to produce a cheaper ultramarine, which was won by a M. Guimet of Toulouse. A series of new discoveries, including the (poisonous) emerald green, and brilliant cadmium yellows, was exhibited at the Crystal Palace in 1851. But as early as 1824 some of the new colours then available were being sold in tin tubes, and the impact on painting in the rest of the century is hard to overstate. To start with, they were used with circumspection. But unlike some earlier inventions, they turned out to be broadly stable and reliable. The Impressionists laid them side by side on a white base to obtain the maximum optical effects, but also perhaps to avoid the risk of rash mixtures. Courbet, one of the closest precursors of Impressionism, shocked his contemporaries by sometimes applying pure pigment, with a palette knife, and Manet strove for a decisive raw impact by the direct application of colour. Both also turned to light grounds half-way through their careers.

The Impressionists were also helped by advances in the theory of complementary colours and again, the state took a hand. Chevreul, an official appointed to the nationalised Gobelins tapestry factory in 1824 to investigate why certain colours seemed to change when placed next to others, wrote an exhaustive treatise on the subject. Artists had always sensed this phenomenon, but its theoretical clarification was of immense influence. One consequence was a further lessening in the need for varnish; greater richness could be achieved by carefully calculated contrasts. In the century or so since they were introduced, experience has shown that the natural relationships between the new pigments are more stable than those between the greens and blues which caused such havoc with Renaissance paintings.

The Impressionists and Post-Impressionists did, however, make free use of impasto, which inevitably poses long-term questions of durability. Initially, in the case of Monet and Pissarro, this impasto was low and evenly distributed over the canvas, so creating no unusual problems. But, rather like the extravagances of some seventeenth-century artists, the ridges and furrows of Van Gogh and Vlaminck could lose in permanence what they gained in expressiveness. The hillocks of raised paint, especially in the later works of Van Gogh, when the practice began to run to extremes, can flake, be crushed in relining, or collect dirt in the crevices. Extravagant use of impasto was itself an early warning sign of the start of a new cycle of mannered over-emphasis on effect.

Fatalistic Fragilities

In painting, the fragmentation of the old order after the First World War was as drastic in its technical as in its stylistic implications. The balance between invention and the disciplines of durability first slipped, and then lurched towards a new and sometimes wilful impermanence. This century has seen not only the final break between the artist and his materials, but a whimsical promiscuousness in the search for effect. In the early decades, the signs of the new precariousness were already there. But there was still a wary continuity of craftsmanship. Monet, talking of the Impressionist revolution in tone, said in 1909 that official salons that used to be brown had now become blue, green and red, 'but peppermint or chocolate, they are still confections'.[15] Artists of the time thought of themselves as still working within the mainstream of the living tradition, despite the startling changes they themselves had intro-

[15] C. Monet, letter to Gustav Geffroy, c. 1915. G. Geffroy, *Claude Monet: sa vie, son temps et son œuvre* (Paris, 1922).

duced. The very sartorial conventionalism of Cézanne, still striking in old photographs, makes the point.

Degas, despite his unorthodox use of pastels (he steamed or sprayed his sticks of pastel with hot water before working them with his brush), was descended in a direct line from the French eighteenth century. This is one of the reasons why his works look so much at home in the gilded frames of that period. The Cubists, too, looked at from today's vantage point, were still technically sober artists. The tentative use of perishable ephemera, such as newsprint, only emphasised their basic conservatism. Thinned, workmanlike washes of monochrome ideally conveyed their flat, geometrical forms, and except where subjected to misguided restoration and varnishing, they have lasted perfectly. Even their experimentalism was measured: Braque, a former housepainter, was careful not to overload his paint with sand when he incorporated it in certain areas to give a gravelly texture.

The pre- and post-war stylistic division is obviously somewhat arbitrary. Figures like Picasso, Bonnard and Matisse span the whole epoch and were all painters in the old sense. But the ramparts of traditional discipline were crumbling; priorities now lay above all in immediacy of expression, and in originality. Science helped to provide the means of achieving the first, if not the second. At an earlier stage the painter had adapted or adopted essentially industrial products. Developments in this field had now filtered through to artists' colourmen. By mid-century, everything was at hand, whether borrowed by the artists or commercially produced with modern needs in mind, such as acrylic resins. Never had the painter been so spoon-fed with ready-made materials. Every stage of his production was now catered for: pre-fixed sealers, primers, fillers and stoppers, under or over coats, gloss or matt, eggshell varnish, additions to retard drying, gels for showing brushwork or thixotropic gels to disguise it, thickening or

thinning agents, wetting agents, etc. etc. Every potential problem in the painting process was foreseen and analysed and counteracting paint-additives concocted to deal with it. A recent commercial catalogue is enough to give a painter nightmares – paint diseases listed include blooming, blushing, crazing, alligatoring, pinholing, cissing, silking, blistering, checking, pawling, dirt collection during drying, flotation, livering, pigment sedimentation, rivulling, sagging, curtaining, tears, skinning, etc.

Some painters, particularly in America, were content to use these synthetic products to obtain impassive 'industrial' surfaces, albeit sometimes in parody. Others deliberately declined to 'follow the instructions', and in their search for individualism, undermined the principle assets of the new acrylic colours – their guaranteed, scientific security. Still others resisted the use of either new or traditional paints, and insisted on starting from scratch by relying on materials at hand, such as kitchen vegetable oil mixed with water and soap to produce a home-made, matt emulsion. Again, centuries of work on drying oils were ignored and the result – not unexpectedly – was transitory, frequently producing a dull, grey bloom.

Before the advent of acrylics, there had been some attempt by the commercial colourmen to resuscitate old media. Tempera and casein (made from skimmed milk) were packaged in tubes. But, in their modern form, they too tended to turn grey and in any case were unsuited to artists whose main preoccupation was to cover extensive surfaces quickly.

Whatever the qualities of the materials, however, the whole approach to their use had changed. The search for instantaneous visual impact overrode any precautions for the future. The spraying of acrylic colours onto unprimed canvas produces an obvious appeal – myriads of small globules of paint attach themselves enticingly to the cotton fibres – but the effect is not even skin deep, a single touch

will destroy the whole structure irretrievably; such paintings are clearly impossible to restore satisfactorily.

Once concern with permanence is dispensed with, anything goes. The variations of painting methods are limitless. Many modern techniques range from the uncertain to the catastrophic. Pouring industrial lacquers and enamels onto flat canvas can be more or less prudently executed. But the tensions of this splattered irregular texture are likely to prove dangerously friable in the longer term, however ingeniously done. Accumulations of drips are now also fashionable, achieved by adding thickening agents to acrylic paint which is applied onto already wetted clots of previous drips. Window cleaning wipers are used to work diluted acrylic washes into the very fibres of perishable canvas, without any preparation. Fluorescent paint (Dayglo-micronised mica plus dyes), which is known to last for a year or two at the most, is popular for its eye-catching effects. Acrylic paint and oil on silk-screen can produce a wry caricature of photography. Thickly encrusted wax and collage give a more chunky finish. Air brushes can be used to spray paint over photographs projected onto canvas, with final touches in oil. The list is endless. In so far as they mind, many modern artists are placing their products unconsciously or deliberately in the hands of fate, and of the resourceful restorer. They are presumably more concerned with the gesture than with its enduring significance.

The canvas now in use is itself another source of uncertainty, as is the sheer size of many modern paintings. The cheaper American cotton canvases (they were previously made of flax) came in about 1900, and by the 1940s had cornered the market. One of the main attractions of cotton for the instant artist is its capacity for absorption, and such painters are unlikely to be deterred by the canvas's tendency to age and yellow quickly, and slacken as it takes in moisture from the air.

Duchamps once described museums as the 'morgues of art'. Today this is true in more senses than one. The accumulation of the ephemera of modern art in the cellars of major galleries poses a problem to which there is no obvious solution, and indeed no sign of any burning interest. The butterflies have had their day, and few are worth putting in glass cases. Unsoundness of structure will cause many of them to decay beyond recognition within a matter of years.

Already in the nineteenth century, Baudelaire had foreseen the problem when he spoke of the 'chaos of an exhausting and sterile freedom',[16] and warned against the danger of abandoning the discipline inherent in evolved schools of painting. Even assuming some archaeological curiosity in future generations, it will not be possible to revive many contemporary works simply by lifting a veil of dark varnish. The fatalistic attitude of painters towards their materials and techniques indicates not simply a lack of belief in the future, but, paradoxically, an innocent assumption that science will cope through restoration with any defects. This assumption, itself perhaps a by-product of our scientific preconceptions, is based on the belief that there is a solution to every problem. This conviction is particularly inappropriate in the field of art. Faced with such an accumulation of impermanence, the conservator of the future will be tempted to abandon his craft in favour of the feather duster.

[16] C. Baudelaire, 'The Salon of 1846', *Schools and Journeymen* XVII.

Chapter Three

TIME AND MAN, RIVALS IN DESTRUCTION

Time must leave its footprint on pictures
as on everything else; that is its beauty.
Edgar Degas[1]

Paintings almost never survive unscathed, to grow old in dignity. The changes wrought by time are gradual, and natural; man-made changes – whether through damage in war, iconoclasm, revolution or misguided restoration – have together inflicted far greater harm. Symbolic of man's search for immortality, the painted image is, nevertheless, at the mercy of every passion, whether religious, political or financial. After so many centuries of mistreatment at the hand of time and man, it is remarkable that the artist can still reach through to us at all.

[1] Daniel Halévy, *Degas Parle* (1960).

The Artist – Creator and Destroyer

Ironically, the first danger can come from the artist himself. There are innumerable tales of a painter's urge to destroy his own work. Whether through pique or criticism (which led Byron to burn a canto which a friend disliked), perfectionism or sheer dementia, works of art have often fallen victim to the rage of their creator. Soutine was perhaps the best-known example: his patron was driven to lock the studio at night to prevent him from destroying his work. Renoir's dealer, Vollard, recounts the artist's fury when Degas returned a portrait Renoir had given him as a present: 'I was with Renoir when the painting was thus brutally returned to him. In his anger, seizing a palette knife he began slashing at the canvas. Having reduced the dress to shreds, he was aiming the knife at the face: "But Monsieur Renoir," I cried. He interrupted his gesture: "You were saying in this very room only the other day that a picture is like a child one has begotten. And now you are going to destroy that face!" His hand dropped and he said suddenly: "That head gave me such a lot of trouble to paint, I shall keep it." He cut out the upper part of the picture but threw the hacked strips furiously into the fire.'[2]

The artist's legendary propensity for getting into debt was often another means of jeopardizing his own work. Recorded cases must be only a fraction of the unknown total. But it is known that Monet destroyed two hundred canvases about to be seized for non-payment of his butcher's bill. Yet tradesmen could have their uses too: several great Vermeers perhaps only survive because they were used to pay his bread bill.

Artists were particularly sensitive about their early work, and frequently did away with youthful experiments, ashamed of any signs of immaturity or plagiarism. While

[2] Ambroise Vollard, *Souvenirs d'un Marchand de Tableaux* (Paris, 1937).

we must assume that Manet started painting earlier, we know of no works before he emerged as a fully-fledged master, although recent X-rays suggest that some may be concealed beneath his later masterpieces. Where pictures were not destroyed, they were sometimes extensively re-worked by artists in later life. Thus Titian's great *Pietà* in the Accademia in Venice, begun in his youth, may have been the last painting he worked on. Picasso makes the point well when he describes his own paintings as 'a sum of destructions' – a reference to his habit of constantly returning to a picture to erase, alter or re-paint passages. The phrase has a characteristically twentieth-century ring, but the practice has always existed.

Hogarth thought that a figure representing Inspiration that he had placed behind his portrait of the actor Garrick was not in keeping with the mood of the painting, so he painted it out. Ingres, on the other hand, added an equivalent figure behind his portrait of the composer Cherubini after the portrait was finished. Mytens, the seventeenth-century Dutch artist, added a tenth child to his family portrait in the Hague, for the excellent reason that the child had been born after the picture was finished.

Moral self-disgust was another motive for the destruction or disfigurement of pictures. Pieter Brueghel is said to have burned his licentious sketches. In 1492 many artists, including the sculptor Baccio Bandinelli, brought their nude drawings to the purificatory fire stoked by Savonarola in Florence. It may have been of some comfort to painters that their works were placed on the summit of the hierarchy of human vanity. In the words of the great historian of the Renaissance, Burckhardt:

On the lowest tier were arranged false beards, masks and carnival disguises; above came volumes of the Latin and Italian poets, among others Boccaccio, the *Morgante* of Pulci, and Petrarch, partly in the form of valuable printed parchments and illuminated manuscripts; then women's ornaments and toilet

articles, scents, mirrors, veils and false hair; higher up, lutes, harps, chessboards, playing cards; and finally, on the two uppermost tiers, paintings only, especially of female beauties. . . .[3]

The sense of purification through destruction was also an element in the Dadaist movement, and was later taken up by action painters. Today the moral fervour is often accompanied by a very wordly eye on the art market, of which Savonarola would scarcely have approved. 'In front of the white paper the painter of today mimes a sadistic rage, stains it, dirties it, throws acid and sawdust at it, burns it, slashes it with a knife, and then carries the precious remains to the art dealer.'[4]

Painters sometimes felt intolerably burdened by the pressures of the great art of the past, and yearned – metaphorically at least – for its destruction. The message behind Duchamps' 'ready-mades' (commonplace commercially produced items which he bought and merely signed) was the sterility of museum culture. He was not alone in his anarchic instincts. Pissarro had similar tendencies of which Cézanne once broadly approved: 'he was not mistaken, though he went a little too far when he said that all the necropolises of art should be burned'[5]. Cézanne himself was, incidentally, frequently to be seen at the Louvre.

The Family and Fellow Artists

If paintings were unsafe in the hands of artists themselves, they could be even more at risk in those of their families. Artists' widows were often driven to sell their remaining

[3] Jacob Burckhardt, *The Civilization of the Renaissance in Italy* (London, 1860).

[4] R. Kleine, *Notes on the end of an image, Archivio di Filosofia* (Rome, 1962).

[5] P. Cézanne, letter to his son, 26 September 1906. Ed. John Rewald, *Letters of Cézanne* (London, 1941).

works piece by piece, even dismembering larger or unfinished paintings. 'The family again, beware of the family',[6] Degas cried in fury when he discovered fragments of Manet's *Execution of Maximilian*, after the artist's death, crumpled up in a cupboard. Manet's wife had been pestered by art dealers into cutting the heads out to sell. Many of Degas' own ravishingly beautiful monotypes of erotic *Scènes de Maisons Closes* were burnt by his brother to protect his reputation. And it was modesty that led Rubens' second wife to destroy some of his most intimate portraits of her after his death.

If Degas was right to be wary of the family, with its dangerously protective instincts and financial vulnerability, paintings could suffer an almost equally uncertain fate in the hands of fellow artists. Vasari describes how Castagno, an early Florentine painter, would derisively score out with his nails the faults he found in other artists' works.[7] The seventeenth-century Italian baroque painter, Carlo Maratta, was once said to have encouraged a disconcertingly brilliant pupil to use a varnish which he knew would degenerate, out of pure envy.[8] Jealous rivalry between two French seventeenth-century painters, Lebrun and Le Sueur, resulted in damage to the latter's works – rumoured to be caused by Lebrun's followers.[9]

Artists' followers also frequently completed, or even repainted unfinished pictures. The risks are obvious, though occasionally otherwise mediocre artists rose to the challenge. Masolino, a rather weak, fifteenth-century Italian artist, excelled himself when he completed Masaccio's frescos in the Brancacci Chapel in Florence. Velazquez'

[6] Ambroise Vollard, *Souvenirs d'un Marchand de Tableaux* (Paris, 1937).

[7] Giorgio Vasari, *Le vite de' piu eccelenti architetti, pittori e scultori italiani da Cimabue insino a' nostri tempi* (Florence, 1568 edition).

[8] R. Ghelli, 'Risposta alle lettere del sig. Filippo Hackert, contro l'uso della vernice sulle pitture', *Giornale delle belle arti* No. 43 (1788).

[9] Boyer d'Argens, *Examens critiques des différentes écoles de peinture* (Berlin, 1768).

son-in-law, Mazo, managed to finish some of the master's works after his death in a style almost indistinguishable from the original. But more often the artist's own work was travestied or completely submerged in undistinguished overpaint by such posthumous attentions.

The Studio

The studio itself was fraught with hazards of the most practical sort. One only has to look at the conditions artists worked in at almost any period, but especially since the Romantics, to imagine the precarious life that paintings often led in such surroundings. Leonardo describes how, in their blessings on holy days, priests would sprinkle pictures with holy water.[10] Nineteenth-century prints show Horace Vernet's studio thronged with students, apprentices, visitors, models (animal as well as human), and cluttered with various costumes, armaments and equipment of all sorts. The draughty, dusty garret of the Bohemian artist must have been equally unsafe. *Plein air* painters of the later nineteenth century exposed their pictures to even greater hazards: the familiar caricature of the Impressionist artist huddled in front of his easel on a hillside sketching a snowstorm from life had its basis in fact. Monet even had a boat fitted out for painting on the Seine. Great artists frequently worked in insecure circumstances, affording ample scope for incidental damage, ruined work, and lost masterpieces.

The Perils of Travel and Exhibitions

Most major paintings are widely travelled: one only has to

[10] Leonardo da Vinci, *Codex Atlanticus*. Ed. G. Piumati, *Il Codice Atlantico di Leonardo da Vinci* (Milan, 1894–1904).

think of the large-scale confiscations undertaken by Napoleon, or the mass migration of works of art from Europe to North America during this century. Travel inevitably brings its own particular perils.

Canvas was, to some extent, first used in place of panel because it was light and transportable for banners and theatrical decoration, as well as paintings. It could be rolled up and easily moved about by boat in Venice, where it was first used extensively. It had been used in antiquity, although possibly for exceptional purposes only, such as for the gigantic portrait of Nero recorded by Pliny.

The export of paintings from Italy in the seventeenth and eighteenth centuries was usually by sea, rather than by road. Raphael's *Madonna di Foligno,* en route from Rome to France, was in the hold of a ship which capsized. Although it was saved it became, as a result of this accident, one of the first panels to be transferred to canvas in the eighteenth century. Artists generally used agents, or other artists, to resuscitate travel-worn works. Poussin and Rubens gave detailed instructions on the unrolling, restretching, varnishing and reviving of yellowed oil paintings after months enclosed in boxes for journeys. In a letter to the painter Sustermans in 1638, Rubens added a post scriptum:

I fear that, remaining rolled and packed for so long, the colours of this newly done painting may suffer a little, and in particular that the flesh tints and white lead may turn rather yellow. But you, being so great a man in our profession, will easily remedy this by exposing it to the sun at intervals. If need be, you have my permission to set your hand to it, retouching it wherever it may be needful as the result of accidents or of my carelessness.

The hazards of the peripatetic life are almost too numerous to catalogue. Pictures were included in the baggage of soldiers: in the Crimean War Russian soldiers carried icons and the Duke of Wellington took the tiny and beautiful *Agony in the Garden* by Correggio with him on all his

campaigns. Vollard's description of how he carried Manet's *Execution of Maximilian* rolled up like a stove-pipe between his legs in a taxi is a vivid reminder of some of the many precarious journeys undergone by major works of art.[11]

Export controls – by no means a new phenomenon – have always bred correspondingly devious evasive tactics, and illegal acquisitions were sometimes even painted over to avoid detection while crossing frontiers. There was nothing surreptitious about the transport of pictures to the salons of the nineteenth century in France. The journey was sometimes undertaken by the artist and his friends, wheeling larger paintings in a wheelbarrow. Nor were such perils overcome on arrival: Emile Zola's description of the salon jury in the Louvre vividly recreates the scene. Those that were not accepted had the famous 'R' of 'Refusé' printed on the back – thus incidentally adding a new imposition on the unsuccessful artist, since the pictures in effect had to be relined before they could be sold. If accepted, they were fastened to screens placed in front of the old masters in the Louvre, until 1855, when the new salon was opened. When the paintings were all hung, varnishing days were held involving not only the final varnish, but also some heightening and touching up with a comparative and competitive eye on surrounding pictures by rival artists. Enormous crowds of up to fifty thousand thronged the salon on a Sunday.

Even today, with an elaborate technology devoted to the transport and environment surrounding works of art, it can be a major trauma for paintings to be sent to an exhibition. They are subjected to changes in temperature, security risks, perhaps altitude pressures in aircraft, and above all the relentless vibrations of long-distance road transport, not to speak of the many dangers of packing and unpacking. Fluctuating humidity at the peak hours of a major exhibition can cause havoc with a canvas, let alone a picture

[11] A. Vollard, *Souvenirs d'un Marchand de Tableaux* (Paris, 1937).

on panel, as the paint strives to keep pace with its expanding and contracting support. Particularly vulnerable are those paintings that have stabilised themselves over many centuries in the cool equilibrium of a church or castle. Their removal to a crowded gallery, with or without air-conditioning, can cause more damage in a week or two than many centuries in conditions to which they have grown accustomed. No one who has had to care for paintings in transit or in exhibitions would underestimate such dangers. The high proportion of casualties, major and minor, are unseen by the public, but give another twist to the relentless cycle of restoration which pictures often undergo before being put back on show.

Many modern works of art, often conceived for a momentary *'frisson rétinien'* (in Duchamps' phrase), scarcely survive removal from the artist's studio. Fragile squirls of impasto, or sprayed droplets of paint cling perilously to the fibres of unprimed canvases, which themselves are frequently excessively large and billow or sag with variations in humidity.

Dealers and the Art Market

Dealers have naturally been closely involved in promoting these transfers, ever since the buying and selling of pictures, often by minor painters, became more systematic in the eighteenth century. The art market has a predictable propensity for adapting paintings to what it sees as the taste of the time, or of a particular client. Lord Duveen, the greatest dealer of the twentieth century, who specialised in the sale of old masters to American millionaires, was once asked why he put such a high varnish on his pictures. His reply was ironic but revealing: his rich clients, he said, liked to see their reflection in the pictures they had bought – a new slant on the medieval donor who used to have himself painted amongst the saints.

Less reputable dealers have resorted to major surgery, such as the cutting up of an unsaleable religious martyrdom into a series of single portrait heads and a couple of innocuous still lives, both of which are likely to appeal to a wider market. Triptychs and predellas (the long strip below an altarpiece) have always been particularly tempting targets for dismantlement.

Astute adaptations of paintings to camouflage distressing details or unwelcome subjects has been another frequent practice. Brueghel's *Massacre of the Innocents* at Hampton Court was adjusted by an unknown hand (though not necessarily in this case for the art market) to show soldiers savagely spearing small parcels in the arms of weeping women. Salome is often made more presentable for the drawing room by the substitution of a bunch of flowers or a dish of fruit for the head of John the Baptist on a plate. Landscapes have often been rendered more saleable by the addition of a hunting scene, and in recent years wigwams are known to have been inserted into snow scenes to satisfy an ethnic nostalgia for North American primitives.

Portraits were sometimes given a more general appeal by the removal of the name of the sitter, or cut into ovals when this became fashionable at the end of the seventeenth century. Just as some Roman busts had removable heads, so faces were also sometimes repainted to fit another sitter, leaving shoulders, landscape surroundings and even clothes and hats unchanged. Royalist collars in elaborate lace were converted to strict Puritan shapes, or – as political fashions evolved – vice versa. The portly Baroness by the eighteenth-century artist Largillière in the Metropolitan Museum in New York, was slimmed by the hand of a later retoucher, and Titian's *Mary Magdalen* in the National Gallery in London had her bustle removed in the nineteenth century, when they were again no longer modish.

By the laws of the market, and by fair means or foul, whatever is in hot demand will be sure to be provided by less scrupulous dealers. Collectors of a particular theme are especially vulnerable. Recent examination of the cricketing collection at Lord's Pavilion in London suggested that some landscapes may have been extensively adapted to suit the subject. The collection of pictures relating to medical history at the Wellcome Foundation in London is well stocked with similar examples. Some of these confections were highly synthetic: the Wellcome contains, for example, a portrait of Florence Nightingale in the style of the seventeenth-century Dutch artist Gerard Dou. Artists who dwelt on particular themes were obvious targets too. The addition of certain favourite characteristics of a painter can transform a minor work into a Canaletto canal scene, Utrillo's Montmartre, a Rembrandt self-portrait or a Corot landscape with nymphs. It was once observed that there were more pictures by Corot in America than he had ever painted in France.

The history of faking is a study on its own. Most restorers quickly learn to approach any unknown picture with a prudent scepticism, and to watch for tell-tale clues. The re-use of old paintings was a common practice by fakers, as well as by artists. Fortunately, X-rays can now help here: a supposed Leonardo once revealed a portrait of Lawrence of Arabia underneath when subjected to X-ray photography. Much has been heard in recent years of the exploits of van Meegeren, the famous Dutch faker of Vermeers. But he had many brilliant predecessors and successors, though by definition the best remain anonymous.

One of the most successful was a nineteenth-century mayor of Sienna, Signor Joni, whose autobiography explains frankly and proudly how he recreated Siennese primitives.[12] He began as a restorer and embellisher, before indulging his more imaginative talents. Like the late Tom

[12.] J. F. Joni, *Affairs of a Painter* (London, 1936).

Keating, the impersonator of Samuel Palmer, Joni did it for daredevilry rather than merely for gain. He particularly enjoyed teasing connoisseurs by producing works which appealed to contemporary art-historical predilections and theories. Later he boasted openly of the technical tricks he used to achieve his effects: a mixture of tobacco water and turmeric, he discovered, produced a persuasive antique patina. He made no bones about his disgust at the discovery of X-rays, which he called '*briseurs d'illusions*', and quoted with approval an article in the *Giornale d'Italia* by Arturo Calza:

Just when Italy is in crying need of reconstituting her prosperity in foreign trade, comes this discovery; it only needed this to disable completely one of the most remunerative of Italian industries. If there was one branch of export trade that was kept really active and flourishing by us in these difficult times, it was that of the export of so-called old pictures, of those works which the genius of our race – surviving intact in the disciples of Leonardo and Titian – so abundantly supplied to meet the demands of the many thousands of people across the Atlantic, who wish to set up with a gallery of old masters. . . .

Less culpably, and sometimes unconsciously, the art market can also dictate the general appearance of an old painting. The nineteenth-century preference was for a 'smoked look' compatible with dark furniture, heavy drapery and gloomy interiors, and the backgrounds of old master paintings were sometimes over-painted in suitably sombre colours to fit the mood of the times. The reaction in our own century has been predictably thoroughgoing in the opposite direction. The public, and some restorers with it, hanker for what might be called the 'stripped-pine' look in their pictures, as in their domestic interiors. Because of the way we see ourselves, the results may as yet be only partially discernible. But they will be as startlingly obvious

in the twenty-first century as the Victorian 'mahogany look' is to us now.

These swings of taste have been particularly extreme in England. Nineteenth-century antiquarianism, with its tinted varnish and love of golden tones, was partly inspired by the massive importation into England, by the 'grand tourists' of the eighteenth century, of works of art from Italy. There was, in addition, a romantic veneration for age and for the old masters themselves: the Claude Glass was a device used by travellers and visitors to galleries, which, when looked through, made a real landscape look like a painting and greatly deepened the tones of an old master.

It is interesting to speculate on why Britain should be particularly inclined to such artificialities. Several reasons suggest themselves. We have a long tradition of collecting, ever since Charles I showed the discrimination and judgement he appears to have lacked in politics by importing a series of major works, including a fine collection of Venetian paintings. Since the Cromwellian interlude Britain has continued to amass an extraordinary accumulation of works of art undisturbed by invasion or serious civil strife, and today the art market has made its capital in London. But some would argue that Britain's position as collector and dealer, outside the mainstream of the great continental schools of painting perhaps accounts for the somewhat insensitive handling of pictures that have found their way to these shores. The same is to some extent true of America, but that is another story.

Collectors

Paintings which survive such manipulations sometimes fall victim to abuse by the very collectors who commissioned or bought them: '*Quod non fecerunt barbari fecerunt Barberini*' – 'What the barbarians didn't do, the Barberinis have done.'

The Barberinis were a rich, Italian, seventeenth-century family who commissioned Baroque artists to refurbish and embellish antique fragments, adding missing limbs and even new detail, and to incorporate classical antiquities, such as old columns and statuary, into new palaces. Eighteenth-century collectors often showed the same disrespect for old paintings, using them as mere decoration and cutting or enlarging pictures to fit into the panelling of favourite rooms. We know from prints, for example, that Tintoretto's *Raising of Lazarus* was cut to fit a new frame. Coypel was commissioned by Louis xiv to enlarge and 'let some air into' the intentionally claustrophobic world of some mannerist paintings in the royal collection by adding extensions to make the subjects less intense. Raphael's *St John* suffered the indignity of having King Louis xiv's coat of arms painted into its middle.

Wildly inappropriate framing was another affront to a picture's integrity. The entire collection in the magnificent palace at Dresden, from Netherlandish primitive to huge, baroque altar-piece was put into identical rococo frames, with disconcerting results. At the beginning of this century, collectors and dealers quickly assimilated Impressionist paintings into the decorative scheme of their rooms by removing their simple white-painted frames and replacing them with carved and gilded, eighteenth-century surrounds.

Prudery

Prudery accounts for a good deal of defacement and destruction of pictures, even by those who collected them. It is perhaps not surprising that Michelangelo's *Leda and the Swan* has not survived; we know from prints that it was unusually erotic. The painting is thought to have been brought to Fontainebleau and destroyed by one of the

Ministers of Louis xiii. The *Last Judgement* in the Sistine Chapel only survived through the last minute pleas of the Academy of St Luke, the painters' union of the time (in fact a confraternity). Daniele da Volterra, a pupil of Michelangelo, was commissioned to veil the figures instead of destroying them.

A hundred years after Savonarola's great fire in 1492, Ammanati, the Florentine sculptor, wrote a confession deploring the excessive nudity in his early work. The Council of Trent issued edicts insisting on modesty in religious images, and the Inquisition threatened to excommunicate painters of carnal scenes. The same urge that led Van Gogh to cut off his ear after listening to conversations with prostitutes led Mazarin, in old age, to destroy all the paintings in his great collection that offended his modesty. The magnificent Orléans collection was subjected to the same treatment in the eighteenth century, and certain paintings, such as Correggio's *Io and Jupiter*, were only saved when Coypel, the King's painter, went on his knees and begged the Duke to spare them. In return the Duke insisted that the artist should overpaint the offending areas with drapery. Ironically some drapery added in this way has today acquired an unexpectedly lascivious look, as the flesh shows through the increasingly transparent repaint.

Politics, Revolution and Religion

The suffragette who slashed the Rokeby Venus by Velazquez in 1914 was acting not from prudery, but in the cause of feminism. We must assume that it was Velazquez's aloof, detached gaze on to the back of Venus which she found so provocative. Sometimes paintings become victims of more random political posturing: the quintessentially private and personal Vermeer at Kenwood, *Lady with a Guitar*, was stolen by a supporter of the IRA. It happened to

be one of the very few completely intact paintings surviving from the seventeenth century; it still had its original wooden nails, put in by Vermeer himself, and had never been relined. Astonishingly, it escaped almost unscathed. Apart from thefts, which invariably cause some damage even when the painting is recovered, certain paintings incite the vandal simply by virtue of their fame. The *Mona Lisa* was stolen early in this century and returned, but then damaged again by a stone thrown at it in 1956. Millet's *Angelus*, a focus of public adoration for half a century, was slashed by a museum guardian. Michelangelo's *Pietà* in St Peter's was also the target for a madman's attack, and the recent slashing of Rembrandt's great *Night Watch* in the Rijksmuseum in Amsterdam is another tragic example.

During the Paris Commune, one of the most symbolic acts of desecration was carried out by a leading artist, Courbet, who took an active part in the toppling of Napoleon's immense sculpted column in the Place Vendôme. But violence directed at works of art was by no means a European speciality. During the Cultural Revolution in China, the revolutionary vandalism of the Red Guards often focused on the country's most accessible aesthetic heritage, and exposed carvings or painting on the lower levels of temples or pagodas were defaced or smashed. Persecution of artists was popular and even posthumous; the tombstone of Ch'i Pai-shih, China's best-known painter of the twentieth century, was toppled by Red Guards.

The biblical proscription of images perplexed and tormented the Church from its earliest days, and culminated in the great iconoclastic movement of the eighth century. The complete interdiction of images is still maintained, not only by Islam, but within the Christian religion by many branches of Protestantism. Yet at some periods no one has exploited the power of imagery – implicitly acknowledged in these interdictions – more effectively than

the Church itself. The magnificent painted ceilings, the sensuous sculpture, and the exuberant architecture of the great baroque churches of the Jesuit order in the seventeenth century were calculated to overwhelm the senses of the congregation. The problem was frequently to restrain this enthusiasm within religious bounds and to prevent the encroachment of worldly detail. In the late sixteenth century, Veronese was interrogated by the Inquisition for introducing 'buffoons, drunkards, Germans, dwarfs and similar vulgarities' into his great canvas *The Marriage at Cana*.[13] Half a century later, Caravaggio was censured for painting St Matthew as a peasant with dirty feet.

Further North, the Reformation had more destructive effects. Some Protestant leaders, such as Zwingli, refused to allow any images at all. The Huguenots ravaged a number of French cathedrals and in Holland the Calvinists destroyed almost all religious painting, though by good fortune one or two masterpieces by the greatest early Dutch painter, Geertgen tot Sint Jans, escaped.

But such cases were mostly unrepresentative extremes. In everyday life, the Church was flexible and pragmatic, adapting itself – and its imagery – to the orthodoxies of the times, while preserving the apparatus of popular devotion. These adaptations took a number of forms; but the common factor was the need to respond to the spiritual needs of the particular place and period.

The cult of miraculous images was tolerated in many parts of the Roman Catholic church, and paintings were sometimes reworked to meet the demand for sentimental religiosity. Canvases were cut to allow silver crowns to be put on the heads of madonnas. Just as many stark romanesque churches were encased in plasterwork during the baroque period, so the staring gaze of primitive icons was sometimes adjusted to convey the swooning ecstasy of

[13] Archives of Venice. Records of Tribunal of the Holy Office for 18 July 1573.

a seventeenth-century saint. The religious appeal of gold proved more constant. It was revived by the Byzantine Church in the eighteenth century by laying gilded covers over icons, leaving only the faces exposed. In the Western church as well, gold leaf, darkened by varnish, was frequently covered by bright gold paint or completely regilded in the nineteenth century, and gold highlights were added to many paintings of devotional significance.

In conservation terms, churches were either havens of security, or prisons where the slow death of the inmates was only a matter of time. Where paintings were in stable, dry surroundings, they were safe for centuries, but dampness caused devastation. The simple effect of humidity upon ancient walls was ruinous both to canvas and fresco. Mould on the back of canvases and rising salts in walls produced rapid disintegration. Again, the best example is Leonardo's *Last Supper*: its tragic history and slow death were charted by Goethe.[14] The monks, in whose refectory it was, cut away the feet of Christ to raise the height of the door. Later, soldiers were stationed there with their horses, whose exhalations accelerated the fresco's disintegration. A subsequent flood did not help.

The Ravages of Tourism

Brunelleschi and Donatello were once mistaken for treasure-seekers when they went to measure the ruins in Rome at the beginning of the fifteenth century. At the time it was assumed that any interest in the ruins was pecuniary. The pillage of historic sites takes many forms: but whether by robbers, archaeologists or tourists, the results can be remarkably similar. Today, as the tidal wave of international travel mounts, there is growing concern about the indirect effects of tourism on the state of works of art. The

[14] Goethe, 'The Last Supper by Leonardo da Vinci', *Kunst und Altertum* (1817).

numbers involved are staggering: some cultural shrines have recently received more visitors in one year than in all previous centuries combined. The Temple of Zeus at Olympia received one hundred visitors in 1932: in 1976, there were more than a million. The Uffizi Gallery in Florence sold 100,000 tickets in 1949 and one and a half million in 1980. The caves at Lascaux had to be closed to the public because of the indirect ravages of the mere presence of humans.

Strange as it may seem, pictures can suffer from being seen. Before photography, travellers wanted to take away copies of famous paintings. Local copyists obliged, and frequently rubbed the original paintings with oil to brighten them for this purpose. (It took over a century for people to see the cumulative damage caused by the practice of taking plaster casts from sculptures, which was only finally forbidden at the end of the nineteenth century.)

Before we wax too indignant, we should remember that museums nowadays have been known to subject old master paintings to special treatments to satisfy the needs of photography. To the author it seems scandalous that Titian's great *Bacchus and Ariadne* should have been affixed to composition board partly, it has been said, to sustain it for its frequent removal from the wall for photography[15]; an unnatural treatment which imposed a perceptible rigidity on the painted surface of the work. Tourism also gives another spin to the debilitating restoration cycle in a number of ways. The very breath exhaled and heat generated by large numbers of visitors causes sharp fluctuations in the atmosphere around a painting. Air-conditioning – even assuming that it functions smoothly – cannot always respond efficiently to large throngs of people. The results can be startling; panels can warp or crack, and paint can flake from canvases as they expand and contract. Multitudes of visitors mean increased security for each picture. One recent

[15]*National Gallery Technical Bulletin*, vol. II, 1978.

solution has been the burglar alarm pad, which presses on the back of the canvas, gradually producing circles of cracks in the paint.

But above all, tourism means money, and it is money which helps to provide the incentive to make paintings 'look their best'. Like people dressed up for a party, pictures are not allowed to be themselves or look casual or dishevelled, but must be tidied up for the public gaze. Subtly and often inadvertently, the emphasis shifts from the picture itself to its presentation. Restoration with a mass, inexpert audience uppermost in mind will influence the methods used. It must be clear and bright to attract the languidly wandering and sated eye, distracting irregularities must be smoothed away, and the outlines or highlights of the work must be strengthened, like so many tourists' signposts.

The analogy with archaeology is instructive: in both cases it is the most favoured works which suffer most, minor objects often existing unmolested for centuries. In the picture restorer's scalpel and solvents bite into the patina of paintings like the relentless probing of the archaeologist's shovel. Objects are prised from their original surroundings, or their surface reconstructed. William Morris saw the dangers when he mounted his great 'anti-scrape' campaign against the removal of natural accretions on old churches.

PART II

Chapter Four

RESTORATION I:
The Uneven Legacy

Disdained by the savage, or scattered by the soldier, dishonoured by the voluptuary, or forbidden by the fanatic, the arts have not, till now, been extinguished by analysis and paralysed by protection.
John Ruskin[1]

In its slow journey through time towards gradual disintegration and extinction, a painting may suffer any of the depredations mentioned in the previous chapter. But few, apart from outright destruction, can have such a devastating effect, and none is likely to be as insidiously corrupting as restoration.

[1] Ruskin, Review of Lord Lindsay, *Sketches of the History of Christian Art* 3 vols (London, 1847).

What we see today is inevitably, in differing degrees, an interpretation. But pictures should not be seen as instruments upon which different restorers play different tunes, according to contemporary fashion. The restorer, unlike the orchestral conductor, is emphatically not a performer; indeed he should deliberately avoid imposing his own personality, or the personality of his epoch, on the work of art in his care. The highest accolade he should aspire to is for a painting to look as though it had never been touched. Ideally, it should never be possible to discern the work of a particular hand, museum or country. In real life, however, individual techniques and national styles differ very widely. It is possible to walk around exhibitions and classify paintings according to where they have been treated, when and even by whom. At the Rubens Exhibition at Antwerp in 1977 the contrast between paintings from America and the Soviet Union was startling, and not in America's favour.

The magical beauty of a painting preserved intact through the centuries, with its surface and texture unstamped by the bustling trademarks of intervening eras, is only equalled by its rarity. Discerning connoisseurs already think it unusual to find an early twentieth-century painting that has not been earnestly tampered with. How much more so a Renaissance or baroque work that has been touched only by time? The twentieth century struggles as never before against age, and yet prizes the antique. The paradox has interesting consequences: one is that much of our restoration work, in striving for 'authentic' contact with the past, succeeds only in producing lifeless relics.

The conservator's prime task is not to remove all traces of age and ageing, but to hold together the fragile unity of the painting, and above all to keep his peace with the ghost of the original artist. Ultimately, this will depend more on subjective than on technical factors, and the power of the

imagination will be stronger than any solvent in penetrating the layers superimposed by time. The minute pattern of cracks over the surface of ageing paintings illustrates the point perfectly. It fits our expectations of an old picture as completely as it does of an old face. Consequently, our eye does not focus on the 'deformity' as something unusual, peculiar or in any way disturbing. Yet a single attempt to rejuvenate areas of a painting by touching out the cracks can draw attention to the entire pattern; everything then begins to seem anomalous and somehow unacceptable. An incongruous freshness or flatness, where our natural anticipations of age are disturbed, induces disquiet. It is a feeling we may be unable to pin down, though we sense strongly the interposition of another disconcerting set of values between the ideals of the painter and the modern beholder. This gratingly discordant note will inevitably echo the period in which the picture was restored. The more skilful the restoration, the more subliminal will be the distorting effect. One might even go so far as to agree with Ruskin that, given a choice, a rough, simple and obvious repair might be more honest. Talking of architecture in *The Lamp of Memory*, he says:

It is no question of expediency or feeling whether we shall preserve the buildings of past time or not. We have no right whatever to touch them, they are not ours, they belong partly to those who built them, and partly to all the generations of mankind who are to follow us. The dead have still their right in them: that which they laboured for, the praise of achievement or the expression of religious feeling, or whatsoever else it might be in those buildings they intended to be permanent we have no right to obliterate. What we have built we are at liberty to throw down, but what other men gave their strength and wealth and life to accomplish, their right over does not pass away with their death; still less is the right to the use of what they have left vested in us only. It belongs to all their successors. It may hereafter be a

subject of sorrow, or a cause of injury, to millions that we have consulted our present convenience by casting down such buildings as we chose to dispense with. That sorrow, that loss we have no right to inflict.

The same principle can be applied to pictures. The great periods of painting recede still further from us, and even since Ruskin wrote, new waves of taste have intervened, often imperceptibly superimposing their style on existing paintings. We must be more than ever wary of doing anything that would jeopardize their future as works of art, or which could complicate the unravelling of such clues as remain as to their original state. The contemporary passion for investigation and analysis should never blind us to the fact that we are trespassing into the very subjective fields of an artist's creation and our own perceptions. The relentless search for the 'truth' of a painting can be like a child pulling apart a flower to find out 'how it works', and inevitably leaving only wreckage behind. The uncovering of the material facts about a picture rarely gets us any nearer to a true understanding of its real genius, still less any attempt at re-constituting that genius. Emphasising the physical surface of a painting by over-cleaning, over-varnishing, or over-painting, introduces irrelevant distractions between the artist's intention and ourselves.

So what should the restorer do? History shows that there are no easy answers. The notion of a return to the 'authentic' is often illusory: changes in the colours themselves, in their texture and balance, and intricate accretions on the surface cannot be reversed. The only certainty is that there can be no dogmatic rules to guide the restorer's hand, no authoritative scientific system to apply across the whole surface of one painting – let alone over all paintings. A variety of infinitely flexible techniques must be evolved by each restorer, and each must be so intimately understood that it is simply an extension of the hand or eye, instantly

responsive to the needs of an individual work. In this sense, if in no other, the conservator is an artist.

The Methods of the Past

The distinguishing feature of contemporary restoration is its power to inflict widespread and irreversible damage on whole generations of pictures. The power results from the unprecedented means at the disposal of modern technicians. The depredations of the past have sometimes been appalling, but they have been on a much smaller and less systematic scale. It is thus possible to argue that previous generations have been kinder in their overall treatment of their inheritance. But there is no lack of precedents for our own somewhat arrogant attitudes. We have inherited an inglorious history of past mistakes. It is worth glancing back for a moment to see how previous generations, imprisoned, like ourselves, in their own time, left their imprint for better – or often for worse – on the works passing through their hands.

The scanty records and recipes of past restorers sometimes make alarming reading. The French eighteenth-century historian, Roger de Piles, had a brisk approach: 'There are many ways of cleaning old paintings when they are darkened and smoky. Some use soapy water with which they rub the picture in every direction with a rough brush.' His cautions are almost equally alarming: 'It is essential not to rub too hard or too long because soap dissolves the colour, particularly that which has been glazed over the top.'[2] Other easily procurable cleaning materials included soda and cinders or potash, boiled up together; alum and salt with urine; and smalt (powdered glass) with ox gall and wine or beer.

Although many of the ingredients used in the past were

[2] Roger de Piles, *Elémens de Peinture Pratique* (Amsterdam and Leipzig, 1766).

fierce, and the methods rash, the results were not always as bad as might have been feared. Some recipes and concoctions were based upon intuitive chemical sense. The ammonia in urine was a handy solvent, and there is plenty of evidence to show that it was put to frequent use. Much depended on how sensitively it was diluted and applied. Another readily available, mild and natural expedient was saliva, which was found to be ideal for the gentle surface cleaning of pictures. There are eighteenth-century records of men being taken on for a day or half day to contribute their spit to the cleaning of a large painting. Still today, there is no simpler or better method for the minimal treatment of a well-preserved picture. Saliva has just the right temperature and enzymes to dissolve grease without penetrating the varnish or eating into the pigments themselves.

Innumerable other homely recipes, involving green apples, potatoes, or onions, are recorded, whose use was often less drastic than it might sound, although the water content of all these patent solutions could be dangerous. Unquestionably deleterious was the practice of rubbing oil onto the front and back of the picture to revive any blanched areas following these treatments. The oil fused with the paint, and over time permanently darkened it.

In essence, many of the picture-cleaning methods employed in previous centuries were merely less refined versions of some of the less noxious practices used today, and if sensitively handled, could produce satisfactory results. Then as now, one way to avoid having recourse to solvents at all was simply to rub off the crystallised varnish by hand, either with powdered resins, or now with a scalpel under a microscope. If solvents were to be used, good craftsmen had more sense than to flood the painting with watery mixtures, which enlarged and loosened the paint. Instead they used – as most restorers do in some form today – a combination of alcohol (or wine) and a diluent such as turpentine.

Thus, despite their often rather simplistic and primitive approach, we should beware of taking too dramatic a view of past methods. Conservation has never been purely a matter of solvents, recipes and equipment. What the conservators of previous centuries lacked in technical resources was often balanced by a high level of craftsmanship and sense of art-historical continuity. Until the nineteenth century most restorers were themselves artists, not only because they needed to earn extra money, but because restoration was seen in many periods as an exacting and worthwhile task for both lesser painters and even, at times, for established artists. It was naturally assumed that only competent members of the profession could presume to touch the great masterpieces, and some great masters themselves did not think it demeaning to help to conserve or resuscitate the works of their predecessors.

The famous *Madonna* by Coppo di Marcovaldo of Sienna was restored and repainted in Duccio's studio, its stiff Byzantine formalism being softened in the process. Lorenzo di Credi, a pupil of Leonardo, restored works by Uccello and Fra Angelico. Van Eyck's Ghent altarpiece was treated by the Antwerp Mannerist, Van Scorel. Verrochio and Donatello worked on the Medici collection. Bramante restored antique statues, as did Michelangelo, whose ability to recreate classical sculpture down to the finest nuance of finish and patina is exemplified by his youthful *Bacchus* in Florence, which was passed off as an original Roman work. Titian himself worked on Mantegna's *Triumph of Caesar*, now at Hampton Court, adding his own painterly touches – in oil – to the artist's more linear distemper original.

Perennial Concerns

In the past at least, artists and connoisseurs have always been well aware of the implications of restoration, its pitfalls

and its limitations. Not surprisingly, they were particularly conscious of the risk of one master imposing his artistic personality on a predecessor's work. Aretino describes Titian touring the rooms painted by Raphael in the Vatican, in the company of a friend of his youth, Sebastiano del Piombo, the great introspective master who formed a link between the artistic communities of Venice and Rome. Unaware that Sebastiano himself had just retouched Raphael's already immensely famous works, Titian asked his companion: 'Who was the rash ignoramus who has thus daubed them?'[3]

Even great artists were not invariably the best restorers, and of course most pictures were, in any case, dealt with by lesser painters. Thoughtful and sensitive men such as Baldinucci, the great seventeenth-century Italian connoisseur, expressed healthy suspicions about the whole concept of restoration. He devoted a section of his *Vocabulario*, a sort of encyclopaedia of the arts published in 1681, to the subject, and defined the problem in a classic statement:

By the term *rifiorire* [to freshen up] a most vulgar term by which the lower classes want to express that insufferable stupidity of theirs, to have an old painting occasionally covered with fresh paint even by an inexperienced hand, because it has been slightly blackened by the process of time. This action not only deprives a painting of its beauty, but also of its air of antiquity. One might call restoration . . . or repair, that readjustment which is sometimes done to a small part of a painting, even of an outstanding master, when it has flaked off or otherwise come to harm in any place; for this can easily be achieved by a skilled hand, and it looks as if no more was taken from the painting than that defect which, however small it may appear, still tends to disgrace and discredit it. There have been many, however, who were by no means totally inexperienced in matters of art and who held that the best paintings should never be retouched, either much or little, by whoever it may be. For it was difficult for the restoration,

[3] L. Dolci, *Dialogues of Pietro Aretino* (Venice, 1557).

be it small or large, not to show up sooner or later, however small it may have been, and it is also true that a painting that is not untouched is always very much discredited. By the term *rifiorire* the ignorant also mean the washing of old paintings which they sometimes do with such lack of caution as if they were scouring a rough block of marble. They fail to consider that one frequently does not know the composition of the mastics and primings and what pigments the artist used (the natural earth colours can stand the lye or other less strong solvents better than artificial ones). And so they run the risk of removing from these paintings during the process of cleaning the veilings, the middle tones and also the retouchings, which are the last brush strokes in which the greater part of their perfection consists. They even risk their coming off entirely in one go – something I remember happening to a beautiful self-portrait by Giovanni di San Giovanni in oil on canvas which was presented to the illustrious Cardinal Leopold for his famous gallery of self-portraits . . . when this portrait was entrusted to an experienced gilder, probably to have it framed, he also wanted to wash it in the same way as he had done in his time with many other paintings. Having washed it the priming and the colour immediately became detached and whatever was on the canvas crumbled and fell to the ground in minute fragments, nothing remaining of the fine picture but the canvas and the stretcher.[4]

Nearly a century later, Monsignor Bottari, another erudite Italian connoisseur, put matters succinctly in his *Dialogue on the Three Arts of Drawing*:

Restorers wishing to clean and wash and being ignorant don't stop at the dust and dirt but carry off all the best and final touches and veilings, as professors call them and the final touches of the master which are the flower of painting. In all, they want not to know the middle way but always to go to extremes which are always vicious; either allowing the picture to disintegrate with humidity, dirt, intemperate conditions or the heat of the sun or with dust or any other disorder; or, on the contrary, to wash it with a thousand pernicious secrets and re-touch and re-paint in

[4] F. Baldinucci, *Vocabulario Toscano dell'Arte del Disegno* (Florence, 1681).

large quantities with ignorant artifice. Which of these two is the worst? I say certainly the second.[5]

Goya made some perceptive remarks when asked by Don Pedro Cevallos to report on the state of some recently restored paintings:

It would be hard for me to exaggerate to your Excellency the discordant effect that my comparison of the retouched parts with those unretouched caused in me, because in those retouched parts the verve and vigour of the paintings and the mastery of the original delicate but knowing touches still preserved in them have disappeared and been destroyed completely. With my innate frankness which is moved by my feeling, I did not conceal from him how bad all this seemed to me. Immediately thereafter others were shown to me and all of them equally deteriorated and corrupted in the eyes of professors and true intellects, because in addition to the invariable fact that the more one retouches paintings on the pretext of preserving them the more they are destroyed, and that even the original artists, if they were alive, now could not retouch them perfectly because of the aged tone given the colours by time, who is also a painter according to the maxim and observation of the learned, it is not easy to retain the instantaneous and fleeting intent of the imagination and harmony of the whole that was attempted in the first painting, so that the retouches of any subsequent variation might not have adverse effect.[6]

No less a figure that Goethe himself took an interest in the issue, and formulated a philosophy of absolute restraint. He too was asked for his opinion on recently restored works, this time in the Dresden museum. Writing in 1816, his view was that: 'cleaning and restoring should be considered only as a last resort and be risked only when a painting had become totally unenjoyable and entirely black in the shadows.' Only then might it be right to lighten the shadows as 'only the areas that have become entirely dark

[5] Mgr G. G. Bottari, *Dialoghi sopra le tre arti del disegno* (Lucca, 1754).
[6] Francisco de G. y Lucientes Goya, *Report to Don Pedro Cevallos*, 2 January 1801.

and unclear are disagreeable and disturbing for the in-
formed viewer.' He condemned attempts 'to make good
old paintings appear as if they were new, for intensive
washing and alleged cleaning of the light parts removes the
so-called patina.' His mistrust of restorers emerges most
pungently from his description of one Bellotti who worked
on the *Last Supper* of Leonardo:

this man, with vulgar salesmanship, boasted of a special secret
with which he undertook to restore the faded picture to life. With
a small demonstration, he deceives the ignorant monks. Such a
treasure is put in his arbitrary care, which he immediately
secretes behind nailed up boards, and then, hidden away, paints
over the work from top to bottom.

He also underlined the responsibilities of those in charge of
works of art:

The owners themselves, who should have been the guardians
and preservers [of the *Last Supper*] caused its greatest degenera-
tion – beyond that of the passage of time combined with the
various circumstances mentioned, and thereby covered their
memories with perpetual shame.[7]

Delacroix commented after a visit to see the restorations at
Fontainebleau in 1832, which had been done by Louis
Philippe's favourite painter, the otherwise completely
undistinguished D'Allaux:

I saw Fontainebleau. Vandalism has made great advances. It is
unbelievable that this lack of reason should reach a point of
ravishing the admirable remains of painting there, all done under
the brush of Monsieur D'Allaux, the Roman.[8]

In his diaries, he also comments frequently on the brutal
treatment of paintings in the royal collection, and in the
Louvre at the hand of Monsieur Villot, its chief conservator.

[7] J. W. Goethe and Heinrich Meyer, *Report on the Restoration of Paintings in
Dresden*, 9 April 1816.
[8] E. Delacroix, Letter to M. Pierret, 8 January 1832.

Amongst the many paintings whose treatment attracted Delacroix's wrath was Raphael's *St Michael* at Fontainebleau. It had already suffered the attentions of a number of restorers, including some famous artists, and had first been retouched under the direction of Primaticcio, the elegant Italian Mannerist painter and protégé of Francis I. in the process, he had taken the opportunity to remodel the pivotal leg on which St Michael balances above the dragon in a frankly Mannerist style, by giving it a distinctively elongated and elaborate twist. The painting was transferred from panel to canvas and twice rebacked in the eighteenth century. It was then given a characteristically romantic chiaroscuro by Girodet-Trioson, the early nineteenth-century French artist, when he took his turn at it. In the middle of the nineteenth century, amidst general consternation, it was subjected to yet another transfer and restoration during which it was reported that Primaticcio's new foot had been removed by Villot. This might seem defensible on art-historical grounds, had Villot not apparently taken off with it much work that was by Raphael himself. Delacroix's indignation was a powerful expression of the artist's perennial awareness of the presumption of the restorer.

Several decades later, in a very different climate of taste, the central issues of conservation remained the same. The restoration of Raphael's *Madonna with the Candelabra*, which was put on sale at Christie's in 1878, provoked an outcry from a French commentator, Charles Timbal, in an article published in *Le Français* in that year:

Through the years the *Madonna with the Candelabra* has received more than one injury. It has suffered; worse still it has been restored. The Donatellesque head of the child has been subjected to mortal attacks by Italian doctors. Their favourite methods are here easily recognisable. They assault the affected areas and cover them up with tiny touches to avoid obvious re-painting

which will always be recognisable whatever one does. But they extend their cure far beyond the ill. This doesn't immediately spring out, but it softens and effaces the primitive urge of the original execution, and its shadows spread over all the surrounding areas. The angels are thus almost completely repainted. The body of the baby Jesus has been cleaned down to the base, and all the finesse of the last glazes, and certain forms of childhood always so beautifully shown by Raphael, have vanished under this pitiless scrubbing. The hair, which the master excelled in making play lightly on the forehead has been heavily repainted in an opaque tone, hardly matching at all the curls that remain intact.[9]

Jacob Burckhardt, the father of modern art history, foresaw the dangers of the increasingly restless existence of the old masters. In some lecture jottings he complained that old pictures were perpetually on the move and went on to say:

But while we are on the subject of futile wishes: old pictures ought no longer to travel much at all and should be left in peace by certain restorers, who get hold of them particularly when they change hands. The transient nature of wood, canvas, layers of colour in themselves; in addition the desire of the owners to make pictures that have become dark once again shine freshly, taking off old varnish and old glazes with it. It is precisely the very famous pictures which are especially unfortunate, and are not allowed to grow old naturally and have therefore been periodically cleaned, overpainted or spotted; few Madonnas of Raphael are entirely untouched; the holy family in Munich [is] a well-restored ruin; the most beautiful landscapes often have ruined horizons.[10]

Even some of the most revolutionary artists of the end of the nineteenth century were ultra-conservative about conservation. Degas once exploded to Daniel Halévy:

[9] Charles Timbal, *Le Français*, 9 May 1878.

[10] 'From great art collections', Notes for a lecture by Jacob Burckhardt, given on 16 January 1883, Jacob Burckhardt, *Vorträge 1844-1877*, ed. Emil Durr (Basel, 1919) pp 458f.

My view is that pictures should not be restored. If you were to scrape one, you would be imprisoned. But if M Kaempfe [a restorer] scrapes the *Mona Lisa* he would be decorated. Think of touching a picture. . . . Anybody who touches one should be deported.[11]

The Advent of Professionalism

It was only in the eighteenth century that restoration began to develop as a distinctive discipline in itself. The impetus to a new interest in the field came from many directions. Firstly, the era was of course one of scientific orderliness, and a more systematic and enquiring approach to life as a whole. An aesthetic stimulus was provided by the freshness and lightness of the newly uncovered wall paintings at Herculaneum and Pompeii in the middle of the century. It does not take much historical imagination to realise how strikingly they must have contrasted with the unhealthy and sombre-looking old masters as they had survived.

At the very end of the century, the arrival of the many 'conquered paintings', taken by Napoleon from the rest of Europe, gave more work and prestige to conservators. There had been some criticism within France of the mass importation of paintings from Italy, but many consciences were salved by the thought of the Louvre as a sanctuary for works of art rescued from negligence 'by the genius of victory, and now restored and vigilantly cared for for the instruction of all Europe'.[12] (There are echoes here of retrospective British justification for the removal of the Elgin Marbles. . . .)

Gradually, as the century progressed, restoration came to be seen as a more serious and systematic business. The

[11] Daniel Halévy, *Degas Parle* (1960).

[12] Rapport sur la restauration du tableau de Raphaël connu sous le nom de 'La Vierge de Foligno'. By citizens Guyton, Vincent, Taunay et Berthollet (Paris, Pluviôse, Year X).

first example of what might be called the modern approach was the studio established by an enterprising Englishman – Pietro Edwards – at San Giovanni e Paolo in Venice. Fortunately, Edwards' attitude was one of prudence and sensitivity. He kept careful records of each painting, which show that after 1778, when the laboratory was opening, seven hundred and sixty paintings passed through his hands – four hundred of them in five years. This is a huge number and suggests that Edwards was engaged in cautious, minimal treatment rather than the more extensive overhaulings of today. Above all, he respected the ideal of 'reversibility', being careful to sandwich any additional retouching between layers of varnish so that it could be distinguished from original paint, and proscribing the use of any ingredient that could not be removed later if necessary.

In France, a prime mover in this more rational approach was the Comte de Caylus, archaeologist and initiator in some ways of the modern concept of the national museum itself, as well as of the museum laboratory. While French painters exploited the new tonality in pastels and water-colour, the same passion for light, bright colours spurred restorers to clean old master paintings more thoroughly. Archaeology had also encouraged a thirst for discovery, and excitement at the possibilities of trying out experimental techniques. Perhaps for the first time in this rather specialised field, the public imagination was caught and enraptured.

One of the first to do this was a French conservator, Robert Picault, who made a number of brilliant discoveries. The main one was the astonishing feat of removing paintings from walls or panels and transferring them to canvas. It seems possible, in fact, that this had already been done in Italy; but whoever had been first in the field, he had failed to achieve the popular acclaim which Monsieur Picault enjoyed. It was he who first removed Raphael's *St*

Michael from its decaying support, and exhibited it at the Luxembourg Palace in 1752, amidst great applause. The methods he employed are still somewhat mysterious – though we do know that he charged an enormous sum for the operation. In reply to criticism on this point he pleaded rather melodramatically that, whilst in progress, the task had demanded the sacrifice of his life and his rest. For the space of the eight months it had taken, he had been forced to spend many nights torturing himself to avoid falling asleep during the most perilous parts of the surgery, and had been obliged to breathe in sulphurous and nitreous fumes from the substances he used.

The eighteenth century also invented its own scientific terminology to explain the ageing and darkening of varnish. The word 'phlogistics' was coined to describe the phenomenon. This pleasing but rather elastic term, with its echoes of alchemy, seemed to encompass a variety of natural observations, from the effect of pollution on paintings to the differential deterioration of pigments. The only explanation offered on the latter point was that colours containing metal were most vulnerable to change on becoming 'dephlogisticated' and carbonised.

In the early nineteenth century the scientific approach continued to gather momentum. But there were misgivings too. As we have seen, informed opinion had always been concerned about excessive interference with painting. But it was only now that there were the first intimations that science was getting above itself and that technical advances were causing as many losses as gains. These doubts coincided with the swing of taste towards mystery, age and antiquarianism characteristic of the Romantic movement.

The impact of Romanticism on conservation was gradual, but pervasive. The new mood took its time to work through to the world of restoration, but the practical consequences were predictable. The enthusiastic cleaning of the eighteenth century slowed down. There were a

first example of what might be called the modern approach was the studio established by an enterprising Englishman – Pietro Edwards – at San Giovanni e Paolo in Venice. Fortunately, Edwards' attitude was one of prudence and sensitivity. He kept careful records of each painting, which show that after 1778, when the laboratory was opening, seven hundred and sixty paintings passed through his hands – four hundred of them in five years. This is a huge number and suggests that Edwards was engaged in cautious, minimal treatment rather than the more extensive overhaulings of today. Above all, he respected the ideal of 'reversibility', being careful to sandwich any additional retouching between layers of varnish so that it could be distinguished from original paint, and proscribing the use of any ingredient that could not be removed later if necessary.

In France, a prime mover in this more rational approach was the Comte de Caylus, archaeologist and initiator in some ways of the modern concept of the national museum itself, as well as of the museum laboratory. While French painters exploited the new tonality in pastels and water-colour, the same passion for light, bright colours spurred restorers to clean old master paintings more thoroughly. Archaeology had also encouraged a thirst for discovery, and excitement at the possibilities of trying out experimental techniques. Perhaps for the first time in this rather specialised field, the public imagination was caught and enraptured.

One of the first to do this was a French conservator, Robert Picault, who made a number of brilliant discoveries. The main one was the astonishing feat of removing paintings from walls or panels and transferring them to canvas. It seems possible, in fact, that this had already been done in Italy; but whoever had been first in the field, he had failed to achieve the popular acclaim which Monsieur Picault enjoyed. It was he who first removed Raphael's *St*

Michael from its decaying support, and exhibited it at the Luxembourg Palace in 1752, amidst great applause. The methods he employed are still somewhat mysterious – though we do know that he charged an enormous sum for the operation. In reply to criticism on this point he pleaded rather melodramatically that, whilst in progress, the task had demanded the sacrifice of his life and his rest. For the space of the eight months it had taken, he had been forced to spend many nights torturing himself to avoid falling asleep during the most perilous parts of the surgery, and had been obliged to breathe in sulphurous and nitreous fumes from the substances he used.

The eighteenth century also invented its own scientific terminology to explain the ageing and darkening of varnish. The word 'phlogistics' was coined to describe the phenomenon. This pleasing but rather elastic term, with its echoes of alchemy, seemed to encompass a variety of natural observations, from the effect of pollution on paintings to the differential deterioration of pigments. The only explanation offered on the latter point was that colours containing metal were most vulnerable to change on becoming 'dephlogisticated' and carbonised.

In the early nineteenth century the scientific approach continued to gather momentum. But there were misgivings too. As we have seen, informed opinion had always been concerned about excessive interference with painting. But it was only now that there were the first intimations that science was getting above itself and that technical advances were causing as many losses as gains. These doubts coincided with the swing of taste towards mystery, age and antiquarianism characteristic of the Romantic movement.

The impact of Romanticism on conservation was gradual, but pervasive. The new mood took its time to work through to the world of restoration, but the practical consequences were predictable. The enthusiastic cleaning of the eighteenth century slowed down. There were a

THE ARTIST'S STUDIO

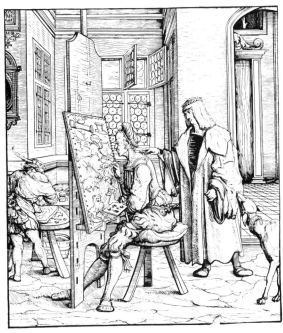

(Left) Hans Burgkmair, *The Artist's Studio*. The artist in touch with his materials: until the 18th c colours were usually ground in the studio itself as can be seen happening on the left of this early 16th c woodcut.

The Impressionists brought a new naturalism, both in their approach to their subjects and to their materials. Daumier, in his *Paysagistes au Travail* (1862) (above) satirises their *plein air* techniques.

RELATIVITIES OF LIGHT

(Left) Francisco Goya, *Self-portrait with Candles*. Goya putting the final touches to a painting by night, illuminated by the candles on his hat.

(Below) Courbet, *L'Atelier* (1885). Courbet's dimly-lit studio contrasts with the stark lighting of today's galleries and restoration laboratories.

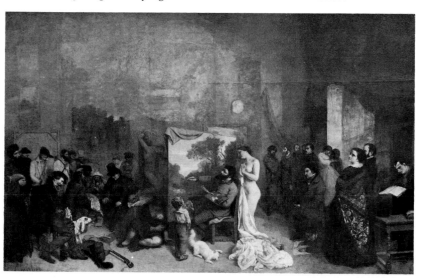

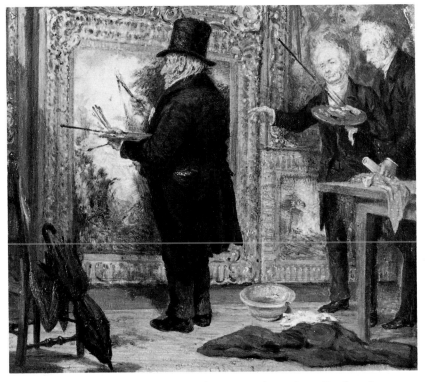

(Above) W. Parrott, *Turner on Varnishing Day at the Academy.* Final strokes, often on top of the varnish, are especially vulnerable to radical restoration.

(Left) Honoré Daumier, *Le Dernier Jour de la Réception de Tableaux* (1846). The pursuit of the perfect finish.

THE HIDDEN IMAGE

 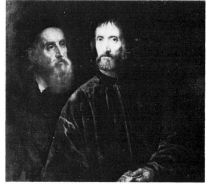

Pictures were sometimes extensively re-worked by the painter – another hazard for the restorer. (Above left) Titian's *Self-Portrait with Friends* as it appears today, (above right) as it appeared before an over-painted third figure was uncovered and (below) an X-ray revealing an earlier portrait by the artist lying at right-angles to the present composition.

(Above) Damage by a vandal to Poussin's *Adoration of the Golden Calf* at the National Gallery, London in 1978.

(Below) Rubens' *Adoration of the Magi* moving into Kings College Cambridge in 1961.

THE INFLUENCE OF FASHION

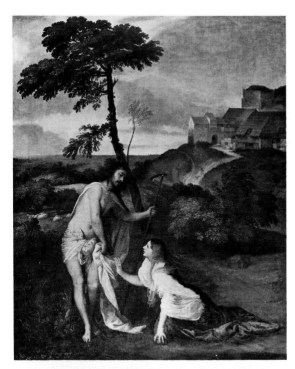

Titian, *Noli Me Tangere* (above) before restoration and (below) after restoration. The bustle on Titian's (or, as some experts believe, Giorgione's) Mary Magdalen was once painted out to conform with a passing fashion. Restoration has revealed the artist's original intention.

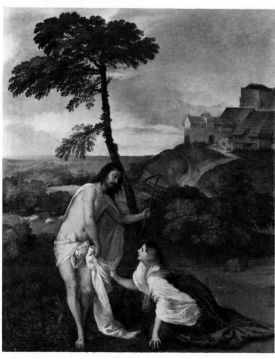

(Above) van Meegeren's forged 'Vermeer', *Supper at Emmaus* and (left) Vermeer's *Head of a Girl*. Forty years ago experts were taken in by van Meegeren's forged Vermeers whereas, only a few decades earlier, real Vermeers like this one sold for only a few florins. Like today's restorers they were prisoners of their time.

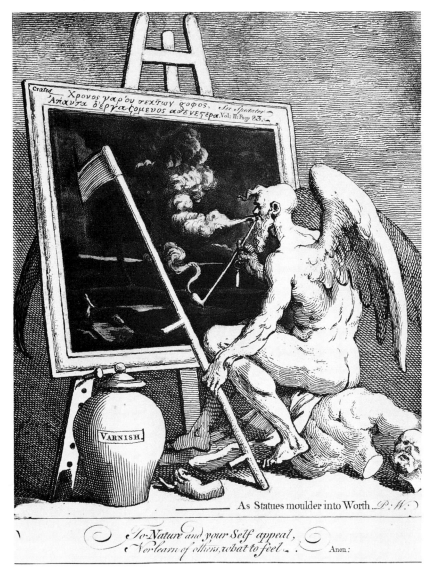

Hogarth, *Time Smoking a Painting*. Buyers will come to distinguish more and more between natural ageing and artificial rejuvination.

succession of *causes célèbres*, involving works by Rubens and Claude amongst others. They culminated in the resignation of the two major figures in the field in England and France: Sir Charles Eastlake, who was later reinstated and became the first director of the National Gallery; and the chief restorer at the Louvre, Villot (who, as has been seen, quarrelled with Delacroix). The offence in both cases was excessive cleaning of old masters, which was no longer acceptable to the taste of the times. This was the occasion of Ruskin's famous broadsides in the columns of *The Times*. He mourned the devastation of Rubens' great *Peace and War*:

> It is for the present utterly, and for ever partially destroyed. . . . Time may, perhaps restore something of the glow, but never the subordination; and the more delicate portion of the flesh tints . . . are destroyed for ever.[13]

He was later to draw very pertinent conclusions on the serious responsibilities of museums:

> So long as works of art are scattered through the nation, no universal destruction of them is possible; a certain average only are lost by accidents from time to time. But when they are once collected in a large public gallery . . . perhaps you may have all your fine pictures repainted, and the national property destroyed, in a month. That is actually the case at this moment in several great galleries. They are the places of execution of pictures: over their doors you only want the Dantesque inscription, '*Lasciate ogni speranza, voi che entrate*'.[14]

In France painters stepped boldly into the controversy, and again the most prominent was Delacroix. In his journal, he argued that although a woman could produce an illusion of rejuvenation by hiding some of her wrinkles, painting was quite another matter. Every single restoration was an

[13] J. Ruskin, Letter to *The Times*, 1853.
[14] J. Ruskin, *A Joy for Ever, the Political Economy of Art* (London, 1857).

outrage, a thousand times more regrettable than the works of time: 'You finish not with a restored picture but with a different picture painted by the miserable dauber who had taken the place of the real artist.'[15]

But these doubts and disputes did not, and could not, affect the scientific research of the period, which in the case of painting concentrated on new media and pigments. Sir Charles Eastlake himself published a comprehensive study of the history of the techniques of painting. Many other great scientists of the nineteenth century, including Chaptal and Vauquelin in France, as well as Sir Humphry Davy and Faraday in England, interested themselves in the analysis of pigments. The discovery of nknown colours in the ancient Egyptian paintings unearthed by archaeologists in Napoleon's train in Egypt stimulated this new enthusiasm. Some of this research had practical consequences for painters: the optical effects of colour, analysed by the great French theoretician Chevreul, inspired the experiments of the Pointillistes.

Research soon strayed into the field of conservation. In 1864, Louis Pasteur himself gave a course at the Ecole des Beaux Arts in Paris entitled 'Lessons of Physics and Chemistry applied to the Fine Arts'. With all the unabashed optimism of nineteenth-century science, Pasteur boasted that:

> If somebody would present him with a Van Eyck in a bad state he would hurry to acquire it to study it chemically – and come up with the result. Why continue indefinitely to discuss whether these masters employed varnish in their pictures to know the composition of the medium. Why not study it chemically? This is the only way, since erudition is powerless.

More relevant to the future of restoration than Pasteur's confident predictions were two inventions of the period – photography, and one of its many extensions, X-rays.

[15] E. Delacroix, *Journal*, 29 July 1854 (Paris, 1893-5).

The first impact of the discovery of photography was on the art of painting itself, but it has since exercised a cumulative pressure upon conservation styles too. Delaroche, the painter, who said of photography: 'From today painting is dead' could hardly have foreseen that the art of the past would suffer too. By its influence on the aesthetic sensitivities of the nineteenth and twentieth century, photography has conditioned – or rather reconditioned – the whole way in which we see forms and colours, which in turn has not failed to transmit itself, via the hand, mind and eye of the contemporary restorer to the innocent images of previous eras.

The profit or loss account of the new techniques is difficult to compute. The advantages of X- and other rays in exposing aspects of the painting, invisible to the normal eye, are nicely counterbalanced by photography's more subjective and subliminal influence, which is less obviously for the good. Photography as an excavatory tool has helped us to see below the surface, disclosing to the prying eye of the modern researcher facets of the painting that its author never intended to be seen. But, in its more everyday forms it has diminished our imaginative powers and our ability to appreciate and respond to the infinite variety of the colour, tone and texture of great painting. The sensitivities of the restorer are no more immune than those of any other viewer to its all-embracing and stereotyping influence.

The Cleaning Controversy

Since the war the controversy about over-cleaning has been erratic, and so far sterile. In Britain the debate was sparked off by the exhibition of cleaned paintings at the National Gallery in London in 1947. Cesare Brandi, the head of the highly respected Istituto del Restauro in Rome, responded

in the columns of the *Burlington Magazine* in 1949 with a discussion of the early use of glazes in Italian painting. Quoting several examples restored at his Institute, he argued that painters from Byzantine times onwards had probably used a thin veiling to soften and distance the raw brilliance of fresh colours:

Vasari, in his *Trattato della Scultura*, repeats recipes for artificial patinas applied in his days to bronze. This gives cause for reflection. The sensibility of Renaissance artists induced them to tone down the brightness, and soften the overpowering impact of newly fashioned bronze. The work of art in which materials triumph we call handicraft: the jewel, the wax, the plate, but not the picture or the statue. The function of patina therefore is to conceal the materials used in the work of art, to prevent it from relying for its appeal on irrelevant qualities.[16]

The subject of glazing and its interrelationship with patina was taken up again in the *Burlington Magazine* in May 1950, and once more in 1962 in a series of debates at the Institute of Contemporary Arts in London with technicians from the National Gallery, led by Helmut Ruhemann. Ruhemann, a former painter, had been given his head at the National Gallery ever since he had been put in charge of restoration there after leaving Germany before the war. He was passionately attached to his views, and disinclined to consider it possible that he might be mistaken. For him, the intensity of the colours themselves was always the dominant factor (although Leonardo himself reminded us in his *Treatise on Painting* that excessive attachment to colours may be compared to fine words without meaning). In his book *The Cleaning of Paintings* he brushed aside the problem of soluble glazes in a few sentences, and does not mention at all artists' final touches on top of the varnish:

As for the often heard and read assertion that many old

[16] Cesare Brandi, 'The Cleaning of Pictures in Relation to Patina, Varnish and Glazes', *Burlington Magazine* Volume XCI, July 1949.

masters, particularly Titian and Rembrandt, finished their pictures with vulnerable glazes, meaning easily soluble applications based on soft resins, this is not borne out by experience. They were too intelligent to use such a vulnerable medium on the surface where the glazes would be the first to be attained by injury.

Patina is dismissed equally briskly. While acknowledging that the term has been used in connection with paintings for many centuries he continues:

the fact that an error is repeated, no matter for how long, does not necessarily make it less wrong. I still contend that the equivalent of a painting covered with a yellow varnish is not a bronze covered with a green patina, but one covered with a layer of mud thick enough to hide its true form.

This is not very complimentary to the considered opinions of people like Goya, Delacroix or Goethe. But Ruhemann seems to have felt that he had a mission to sweep away the accumulated misconceptions and metaphysical clutter of previous centuries. Historical discussion of the subject was seen by him as an excuse

to legitimise the popular 'golden glow' . . .; such old texts were invoked and often misinterpreted: but fortunately not everybody shares the reverence of some for everything written or said a hundred years ago or earlier. A great deal of nonsense has been uttered at all times and an artist's offhand remark need not be regarded as considered opinion.

While admitting that damage done by reckless cleaning was irreversible, Ruhemann claimed that more serious harm had been done to the intentions of the old masters by retaining a patina which for centuries had falsified their works, and had led to erroneous judgements in the literature of art. He appears to have felt an almost apocalyptic urgency in his approach to restoration, as if he were engaged in a race against time:

The possibility that some of the finest masterpieces may one day be exterminated by the H-Bomb has to be seriously faced. Does not this thought suggest the urgency of producing as quickly as possible large colour facsimiles . . .? However two conditions would have to be fulfilled: the reproduction would have to be of insuperable quality (many more plates than four would of course be used and better processes than half-tone) and the originals would all have to be cleaned first.[17]

Ruhemann goes on to investigate in detail the idea of colour reproductions, and rather oddly suggests that painters might perfect them: 'Perhaps it is the colour reproduction that will save the great masterpieces from oblivion.'[18] To many, Ruhemann's judgement has always seemed idiosyncratic. These remarks hardly seem evidence of the mature, detached reflection one would hope for in a man entrusted with one of the world's greatest collections of masterpieces.

In the debate, opposition to radical cleaning was led by Professor Gombrich of the Warburg Institute, and his colleague, Professor Kurz, together with an experienced and reflective scientist from the Courtauld Institute, Professor Stephen Rees Jones. Basing his argument on the study of classical, Renaissance and later writings, Professor Gombrich suggested that it is by no means unlikely that veiling layers were used by many Renaissance painters who may have been stimulated by Pliny's widely read account of the methods used by the great painter of antiquity, Apelles. Both he and Professors Kurz and Rees Jones strove to show that the problem was less simple than the National Gallery restorers seemed to think, and that to the complications about original glazing and veiling must be added those resulting from the chemical changes of

[17] Ironically, Degas once described excessive restoration as a sort of 'bombing' during an outbreak of anarchist explosions in Paris in 1895.

[18] H. Ruhemann, *The Cleaning of Paintings* (London, 1968).

pigments, and the alterations and accretions of time. Professor Gombrich summed up his views in these words:

He [the restorer] has to choose between various known and even unknown evils. His only consolation must be that he is not alone in this plight among those who are concerned with the evanescent art of the past. The Shakespearian actor faced with a rhymed couplet which no longer rhymes because language has changed, the musician confronted with orchestras in which a genuine harpsichord hopes to blend with violinists using modern bows, the translator of a libretto or the restorer of ancient buildings, each of them has to decide from case to case which of the necessary transpositions will do least harm to what he considers the intended totality of relationships. The case for conservatism is quite simply that the slow inevitable changes of time are perhaps less disruptive of this precious interaction than any violent interference can be. Of course where the structure as such is threatened with extinction we must intervene and save what can be saved from the ruin. When varnish goes blind it has to be removed. But should it not be common ground that the aim must be the conservation of our heritage as long as possible rather than the restoration of a condition which is beyond human recall? The 'restored' cathedrals of England, France and Germany are sufficient reminders of what can happen when renowned experts claim to know the intentions of bygone ages. Today few scientists, historians and indeed restorers still need convincing that our evidence is always incomplete and our interpretations always fallible. Only one thing is quite sure: as the American roadsign warned: 'Death is so permanent.'[19]

In reply the National Gallery attempted a purely technical refutation. Joyce Plesters, an experienced member of the scientific staff of the Gallery questioned the degree to which glazes were soluble, though Professor Rees Jones stressed the danger of the leaching of the media in the paint film, which in his view was especially lethal where glazes

[19] E. H. Gombrich, 'Variations on a Theme from Pliny', *Burlington Magazine*, February 1962.

consisted almost entirely of medium. Such leaching was particularly likely to occur during radical cleaning with acetone.

These exchanges were as unsatisfactory as they were inconclusive. The National Gallery tended to caricature the stance of their critics, depicting it as an argument in favour of heavily tinted varnishes – even though the original Pliny quotation had actually stressed the extreme thinness of the film:

He [Apelles] used to give his pictures when finished a dark coating so thinly spread that, by reflecting, it enhanced the brilliance of the colour whilst, at the same time it afforded protection from dust and dirt and was not itself visible except at close quarters. One main purpose was to prevent the brilliance of the colours from offending the eye, since it gave the impression as if the beholder was seeing them through a window of talc, so that he gave from a distance an imperceptible touch of severity to excessively rich colours.

The dispute was complicated by disagreement over the exact translation of this passage. Feelings ran high, although there were some flashes of humour, as when Ruhemann accused Professor Gombrich of 'liking dirty pictures'. In essence Professor Gombrich's argument was that, though naturally much of the original finish will have been lost, it is not necessarily right to act as though it had never existed. The remaining traces, together with a thin layer of old varnish, may be an inadequate substitute, but it would at least be one that the artists would recognise.

Chapter Five

RESTORATION II:
Principles and Modern Practice

We murder to dissect
Wordsworth

Each painting is unique and contains the secrets of its own history. Experienced restorers will be neither surprised not disconcerted to come face to face with pictures about which little or nothing is known, and whose attribution and dating may change as successive layers of repaint or other disfigurations are removed. Minute, even microscopic, marks may be the only clues left to posterity of some phases of the painting's history. The prudent craftsman will always expect the unexpected, be resigned to the inexplicable and treat the picture he is working on accordingly.

His first impulse must not be to subject it to technical

probing, like a faulty radio set or dislocated dishwasher. Instead, he will place it on an easel or a wall to contemplate at leisure and in its entirety as a work of art. Indeed, throughout its treatment, the restorer should spend almost as much time looking at the picture as working upon it.

Good painting has many layers of meaning which emerge only slowly. One simple and apparently obvious way to attune oneself to a picture, but one which is too rarely used, is to read any relevant historical material and to discuss it with art historians. Regrettably, there is often a tacit mutual disdain between restorers, who are sometimes treated as the mere technicians they too frequently are, and art historians, who for their part can be surprisingly unfamiliar with the structure of paintings. Needless to say it is the picture itself which suffers from this reciprocal incomprehension. In recent years the balance of power between technicians and theoreticians of art has shifted drastically towards the former, reflecting the supremacy of the scientific method that has pervaded the profession. There is no doubt that if Goethe or Goya were alive today they would argue forcibly that it is in the interests of the painting itself that the balance should be moved back to the centre.

It seems obvious that the conservator should stand midway between scientist, artist and art historian, with an understanding of all three disciplines. His craft is neither a full science, a creative art nor an academic study. Yet he has something to offer each in return; the long experience of a wise restorer can enormously expand art-historical knowledge, filling out fragmented texts and illuminating assumptions behind them. As it is, art historians sometimes lack a proper awareness of the physical and optical facts of painting, and of the changes that have produced the work they see today. There is a tendency to concentrate sometimes exclusively on the iconographical or documen-

tary aspects of images. But it is no use constructing hypotheses upon an area that is obscured by dirt or completely or partially repainted, or inferring nuances of style from extravagantly over-cleaned works.

Conversely, restorers without art-historical guidance may easily misconstrue important passages in pictures. As the treatment progresses, and new areas of the painting come to light, consultation should be continuous. The conservator would do well to be frank about the possibilities and limitations of his craft. Full discussion of all the perils and probabilities throughout the restoration of a major work of art is of crucial importance. The competent obfuscations of science can be ultimately as damaging as the old mystique of professional secrecy, which it has now partially superseded.

Seeing into the Picture

In an ideal world, each restorer would be handed two dossiers together with each picture. The first would not be merely a sheet of dry documentation on its provenance, but should include discussions on this and any other pictures by the same artist, together with any writing that helps to place it firmly in the context of its time. The second dossier should include a full technical report on the picture: analysis of the pigments, a cross-section of the paint sandwich, and every kind of photographic evidence.

By focusing on different parts of the spectrum, such photographs reveal different things about the picture. An X-ray will penetrate more deeply than an infra-red ray. The first will show each layer through to the canvas, or to the panel itself; while the second will focus on the layer just below the surface, revealing for instance the preliminary drawing for the painting.

By a fortunate chance, lead – which was used in white

paint – is very opaque to X-ray. In this way the highlights in the picture, and any brushwork which contains white, are immediately readable on an X-ray film. Properly used, this form of photography can add an extra dimension to our understanding of the style and quality of the painting as well as the technical composition. It can help the naked eye by revealing whether the final effect that we see on the surface has been achieved by poor and tentative under-painting, or by the sure, unerring touch of a master, thus providing what might be conclusive support for the attribution of a painting to a particular artist. Such evidence will often still remain as subjective as stylistic judgements inevitably are. It will also be patchy: although most flesh painting contains white, and so shows up under X-rays, organic or earth colours – which may be used in the shadows – will not be visible. Moreover, since the Impressionists, lead has been largely superseded by titanium white, which is scarcely readable on an X-ray film. For most recent paintings, therefore, X-rays are of more limited value.

Infra-red photography, by exposing the initial sketch or drawing for a picture, can also help as a guide to quality as well as enabling us to trace the basic structure and evolution of the artist's original conception. Infra-red has a forensic function, too: its power to detect half-erased or disguised signatures is as invaluable for owners and dealers as for academics.

Ultra-violet rays can show up very clearly any disturbance in the topmost layer of a painting – the varnish. Again the advantages are as great to the dealer as they are to the purchaser or restorer. Any embellishment or damage disguised by extensive retouching will normally be visible under an ultra-violet lamp, which makes the varnish glow with a green fluorescence, leaving the repainting standing out in dark patches. Sodium light is a more specialised tool. By penetrating the varnish and giving a clear view of the

paint surface, it can give a useful and sometimes unattainable vision of what a painting will look like once the curtain of discoloured varnish has been removed.

But it is surprising how much can be done without resorting to modern means at all. In examining a painting, the simplest methods can sometimes be the most efficient. Nothing is quite as revealing as raking light for an instant check on the overall condition of the painting. Plain black-and-white photography under such a light, besides highlighting incipient problems such as blisters or irregularities, can bring out the main characteristics of the artist's brushwork and techniques.

If the varnish and paint have badly deteriorated, the mere business of seeing into the picture can be a problem. The light bounces off the multiple cracks in the old varnish and dried-out paint, robbing the painting of the lubricant which enables the light and thus the eye to reach through to the colours. Colour depends on light. As the oil ages, the paint gradually grows more transparent and the light is able to penetrate more deeply. However, simultaneously the varnish will slowly be becoming more opaque and finally crystallising. Its myriad facets will then reflect the light away from the picture, impeding the access of the eye, and the picture will be covered in a whitish bloom. The whole phenomenon is nicely illustrated by H. G. Wells' *The Invisible Man*, who concocted a brew to make himself of the same refractive index as air, so that light could pass straight through him (being an albino he had no pigment to impede the light!).

One of the restorer's tasks is to re-establish a refractive index which is as close as possible to that intended by the artist. In most cases this will involve removing obstructive old varnish and attempting to regenerate opaque, blanched paint. This latter area is one where conservators await further help from scientists. In other areas of the picture, the problem may be one of excessive transparency, for

example of worn glazes. Here the aim is to recover some of the original opacity – another field in which scientific research could be of enormous importance.

The simple microscope is of obvious value both for diagnosis and for treatment. It reveals detailed aspects of the artist's materials and technique, such as the size of pigment particles, and whether they were ground by hand or machine. This can be an important clue to the date of the picture. Any later paint which crosses the natural cracks on the surface of the original will also be immediately visible under the microscope, and over-paint can be removed more safely beneath its lens.

All these methods of examination and analysis can be done without interfering with the picure, which should be regarded as sacrosanct. But sometimes it is legitimate to remove minute samples with a scalpel to analyse a cross section of the paint. Many techniques now exist to identify each pigment precisely. Identification of the medium is a much less exact science, and crucial areas of uncertainty remain. It is easy to be so carried away by the forensic thrills of the analysis of pigments that the other half of the story – the medium which is the water in which the coloured fish swim – is overlooked. Another field where neither of the restorer's dossiers will be of much help to him is the patina, which will differ with each picture, and which defies accurate analysis. The true craftsman will draw fully both on art-historical and scientific knowledge. But in the end, as when he first sees the painting, nothing can ever replace the discerning eye.

Craquelure, Patina and Pentimenti

Atmospheric variations alone can affect the components of the picture in multiple ways. The canvas expands and contracts with warmth, damp and dryness. The resultant

stresses – together with the gradual drying of the paint-layers – produce cracks on the picture's surface. For some, craquelure has an aesthetic value in itself: the Chinese deliberately produce a beautiful web of cracks in some of their porcelain. The infinite variety and intricacy of craquelure can reflect the biography of a painting, as of a face. A history of a canvas or a panel can often be traced by this suggestive network, since different periods and techniques leave a different tracery. The vicissitudes undergone by a painting leave their mark as surely and as individually as a fingerprint.

Patina is the by-product of time, and in the case of painting is an accumulation of a number of facets of the ageing process. The craquelure itself is one. The slow transformation of texture and transparency undergone by each pigment and medium is another; and the interaction with a deteriorating varnish a third. The overall effect is as distinctive, evocative and intangible as the vintage of a wine.

Scientific analysis of the phenomenon is a complex and uncertain process. We are dealing here not only with the differential impact of time on each layer of the painting, and the cumulative consequences of exposure to light on its surface; but also with the effects of slow bombardment by airborne substances, of pollution, and of ultra-violet light on the molecules close to the surface; of the fading of some pigments, and the darkening of others; of the slight separation of media from their pigments into a lens-like film; and of the interrelationship between varnishes and media.

The very existence of the phenomenon of patina is hotly disputed in some quarters, though rarely by painters themselves. Artists of all periods have recognised, and indeed sometimes relished it as a natural product of ageing. The heightened consciousness of Renaissance painters of their own place in history, their ability to infer from ruins

the greatness of Roman civilisation, and masterpieces of sculpture from fragments, made them acutely aware of the passage of time, and of its intricate effects.

Natural patina is infinitely varied and suggestive in different lights. We know that Leonardo was fascinated by its evocative effects on old walls, just as he recommended listening to the sound of distant bells, or looking into the embers of a dying fire as a stimulus to the imagination. He attempted to incorporate such softening and subtle variegations into his paintings to rival the richness of nature, and to avoid hard lines and flat surfaces which left little room for the play of fancy. This was the basis of his development of *sfumato* – the deliberate blurring of transitions. (We also know that Michelangelo was impressed by the unfinished potential of damaged antique torsos, though whether he left his own works incomplete deliberately is still much debated.) The importance of patina was understood by later artists too: Renoir once said that only good pictures could support patina – meaning that superficial, skin-deep contrivances would not stand the test of time, and that only well painted works would retain their dignity in maturity. Pissarro, in recommending one of his pictures, said that, though it was rather 'barbarously' painted ('*de facture barbare*') 'with time it will become softer' ('*un peu moins fruste*').[1]

The disputes about the exact composition and aesthetic value of patina, and about how the restorer should deal with the phenomenon will no doubt continue. To some it will always remain anathema – assuming they admit its existence – or an excrescence to be swept away. The danger of such an attitude is increased in our own day, when patina risks being seen as evidence of decomposition, a *memento mori*, unacceptable to an age which hallows youth.

Increased transparency of a painting with age can reveal ghostly first thoughts of the artist, and aspects he did not

[1]·Camille Pissarro, letter to Heymann, 29 August 1884.

wish to be seen. 'Pentimenti' are places where an artist changed his mind and covered over his original work. Such passages – the adjustment of a head or a hand, or the redraping of a cloak – float to the surface, as the veil of opacity is lifted by time, sometimes confusing the final outline and image. These apparitions can be of archaeological interest to the art historian; but a three-eyed or six-fingered figure can be disconcerting to the layman. It may sometimes be advisable to coax these phantoms back into obscurity, if they are too obtrusive.

The Pressures for Action

The first practical decision the restorer faces is whether to do anything at all. There is a regrettable assumption that, because a picture is not in pristine condition and has not been cleaned for some years and because the modern means are there to do it, it should be done. The sad fact is that if there is money to restore a picture, it will probably be treated whether it needs attention or not. It is equally true that, if a dealer thinks a painting would look better and fetch more on the market by being spruced up and titivated a little, it will be given suitable treatment, which might indeed increase its appeal to contemporary taste, but is almost certain to diminish both its integrity and life-expectancy in the process.

What is often forgotten is that each restoration, however minimal, is a minor drama for the painting. There are often strong arguments for leaving pictures alone for decades. Provided the basic structure is sound – and this can easily be ascertained – many pictures can manage for long periods without any interference apart from the removal of dust. Real damage is done by seeing old masters as a challenge to modern technical ingenuity.

Administrative pressures for action can be remarkably

persistent. They arise not only from the belief that conservation is a 'good' activity in itself; but that it enhances the prestige of the department, museum or gallery in question. There is also the hope that such activism will attract funds from government or private patrons – rather as people gave money to orphanages in the nineteenth century to save souls. And when times are hard and funds are short for new acquisitions, a refurbished painting is a plausible substitute for a new one and can be put on display to draw the crowds. Galleries today are often restless places which have to justify themselves and 'sell' their product by competing for public attention. The lure of 'new lamps for old' will keep the museum in the news and intrigue the public, which is sometimes more concerned with novelty than with the paintings themselves. A new slant on an old master, achieved by a dramatised restoration, can titillate public curiosity in the same way as a scandalous new biography arouses prurient interest.

Fortunately, there have been some recent efforts to counteract these tendencies. The Standing Commission on Museums and Galleries concluded in its report on conservation in 1980 that 'neglect may cause less damage than injudicious intervention'.[2] In its study of the Ethics of Conservation the report also stated:

Science has developed a large range of instruments and methods at the disposal of the restorer from X-ray to spectroscopic analysis to locate and diagnose these departures from the original state of the work, but it cannot offer any guidance about the strictly ethical problem of the course to be taken. Curators have to decide whether the damage is to be revealed to the full, presenting to the visitor an interesting but unsightly ruin, or to be covered up and the whole approximated to what the original appearance may have been.

Whatever course is ultimately steered between conservation

[2] Report by a working party, *Conservation — Museums and Galleries*, Her Majesty's Stationery Office (London, 1980).

and restoration it is clear that the term 'cleaning' is rarely adequate to describe the complex operation. There is no responsible restorer who is not humbly aware of the limits of our knowledge. He will prefer not to make any claims which cannot, in the nature of things, be substantiated, particularly since the perceptual effects of any intervention are even harder to predict in the treatment of a painting than they are in that of sculpture. He will be aware, moreover, that in assessing these effects he will frequently have no other guide than his own aesthetic judgement. Since it is impossible to eliminate this subjective element altogether, he must be on his guard against the bias created by the taste of his own time. It is common knowledge how strong the influence of such preferences has been on restorations carried out in the past; how far they still operate only future generations will be able to tell. One corrective, however, is more readily available today than it was to former practitioners: the history of art has accumulated a large body of evidence from written sources and from the study of works of art about the procedures and the standards of various cultures and periods. The results of this research must not be ignored even where they appear to go against the inclinations of contemporary taste.

Fortunately, there are still some countries and galleries where pressure for action is resisted. For a mixture of reasons – cultural conservatism, technological constraints, and the virtual absence of market and media pressures – Soviet paintings have a quieter life. Decisions on restoration are taken only after long reflection and consultation, and with due consideration for the picture itself. Frequently it is decided to limit intervention to regeneration of the existing varnish. (This often is by the mild Pettenkoffer method, a way of reviving the varnish done through alcohol fumes without touching the paint surface though even this treatment is used with great circumspection.) The benefits of this greater prudence can be seen in many of the pictures in the Hermitage in Leningrad or the Pushkin Museum in Moscow.

Soviet restorers, while respecting some individual Western practitioners, are appalled by the excesses committed by some galleries. One Russian, commenting wryly on an exhibition of Impressionists which had just undergone radical treatment in an American museum, told me that they now looked as though they had been 'painted with toothpaste'.

The Louvre in Paris has a similarly serious attitude to its paintings. It was recently decided for example not to touch Raphael's *St Michael* (whose complicated history has already been mentioned). After careful consideration, the judgement rightly came down against the risks involved in attempting to strip away successive layers of the painting's history. The Louvre is an outstanding example of a serious approach by both craftsmen and art historians, with no predisposition to restore for restoring's sake. Naturally, in such an immense collection, there is a number of grimy paintings needing attention. The French themselves admit that there is much to be done, although preservation is of course the first priority. But those who rebuke the museum for the cautious pace of its cleaning programme should remember that, whereas immoderate conservation is irreversible, restraint has the inestimable advantage of leaving the future open.

The Italians have the enormous benefit of a continuity of tradition. The impressive work done since the floods in 1966 in Florence, and continuing to this day in the Fortezza del Basso, the restoration centre of the Uffizi Gallery, is an excellent example of what can be achieved by restraint and imagination. But Italy has another tradition – that of city states, and there is a wide divergence of restoration styles. Holland and Belgium have a similarly mature approach, based on a deep understanding of their own painting.

The Restorer in Action

Once a decision to restore has been taken, the craftsman must look to his tools. The most important are the solvents. Today, when the variety available has grown enormously, the choice itself should involve careful reflection. They range from relatively innocuous fluids, such as white spirit, at one end of the scale, to much fiercer and corrosive substances such as acetone or ammonia. As in other fields there is a strong temptation to use solvents unsparingly in order to produce instantly gratifying effects. The consequences of misuse can be profound, if not at once, over a length of time. Solvents act crudely, seeping into layers where they are not wanted, and embrittling the paint by extracting the medium and leaving it shrunken and dry. Quickly evaporating chemicals, like acetone, can leave a blanched effect, usually indicating an impoverishment of the paint film. But every solvent, even the mildest, can cumulatively weaken the paint. There are limits to a picture's endurance as to how much it can absorb, just as there are to the amount and variety of drugs that can be given to a sick man.

The restorer may need to leave the painting for long periods to convalesce, as it were, while the solvent evaporates, before he touches it again. The parched and wizened look of paint subjected to excessive applications of chemicals can be superficially disguised by giving it a new gloss with varnish. But this deceptively simple countermeasure, although it will usually have the immediate effect of reversing the blanched appearance, cannot repair the damage which is already done. The physical consistency of the paint will have been irrevocably changed by the rearrangement of its molecules. No easy coat of varnish can hide from the discerning eye the loss of the more rounded richness of the original.

The first time the restorer will touch the painting will be to make a number of tests in one of its least unpredictable areas,

using a solvent suitable for that particular varnish and period of painting and applying it with swab or brush. He may choose a solvent for its virtues of strength, or for its speed of evaporation (acetone for example), which will quickly remove the old varnish – assuming that he is thinking of removing it. Alternatively he may wish to use a more slow-acting solvent, such as alcohol, or to add a diluent, if he wishes to retain some or all of the previous varnish by regenerating it – renewing its life by joining together the crystallised particles into a new clear transparent film. Already he faces multiple choices: he can retain the old varnish; he can thin it, keeping only a fine film; he can remove it entirely; or he can clean some areas more than others. Testing to estimate the possible results of different levels of cleaning is essential. It is by opening small windows through the varnish onto the painting beyond that the restorer can gain a first idea of the possible past and future look of the picture.

Whatever choice or cocktail of chemicals is selected, it must be remembered that different parts of the picture will react differently to their use. In some places it may be necessary to use stronger solvents to remove overpainting: in others the restorer may limit himself to leaving old varnish on the picture because it has become too indissolubly linked to the painted surface, because the area is too fragile, or because the general unity of the picture demands it. He may decide that the painting is too damaged to warrant cleaning at all, or that, while early repaint must be left, later additions must be removed.

The dangerous doctrine of the 'safety margin test', adopted by the National Gallery in London and by some American museums, is an attempt to bring an objective technological system to bear on the whole subjective problem of cleaning. A small area is tested with solvents strong enough to remove varnish until no more varnish and no paint is seen on the swab. This type and strength of

solvent is then considered safe to apply to the entire painting. This school of cleaning ignores the whole issue of defining the boundary between paint and varnish, which, moreover, can vary in different parts of the picture.

This same obsession with hygienic homogeneity is seen too in the use (or rather misuse) of ultra-violet lamps to ensure that all varnish is removed – another clear example of the dangers of over-reliance on technology. It also takes no account of the fact that many painters of all periods glazed *over* the varnish. An eyewitness of Claude Lorrain in 1668 said 'he has already put the varnish on and is in course of retouching the blue and perfectioning the final touches.'[3] Delacroix wrote in his diary for 7 February 1849:

> While I have been working on my picture *The Women of Algiers*, I have discovered how pleasant – how necessary even – it is to paint on top of the varnish. The only thing needed is either to find some means of preventing the varnish underneath from being attacked when the top coat of varnish is removed at some later date. . . .

The technician can easily remove traces of the original work of the painter in his determination to achieve a misleading clarity and uniformity – both twentieth-century priorities.

But this is by no means to say that science cannot be of great benefit, if put to the right use. It *is* possible to use ultra-violet light, but for the purpose of ensuring that the restorer has not penetrated the lowest layer of varnish, especially where it is known that the artist has worked on top of it, and where some traces of this work may remain. Machines cannot be used as a shortcut to critical knowledge, and stripping a painting is often just renouncing a difficult judgement.

The Avoidance of Extremes

The first duty of the restorer in action is to avoid extremes. At

[3] J.–J. Morper, *Münchner Jahrbuch der Bildenden Kunst* (1961) p 124.

one end of the spectrum there is the danger of sanctifying age itself. Age is associated with death, whereas the restorer's job is to preserve the vital aspects of a living image. Those who believe in dirt for dirt's sake are really arguing that a picture must look old, rather than good; dead rather than alive. Malraux saw the point when he said of patina and the changes of time that 'it was not the vestiges of death that grip us in them, but those of life.'[4]

The deliberate refusal to contemplate touching a picture caked in yellow old varnish and sheer dirt, even where this could be safely done without risk to the painted surface, is a perversion, because it implies that we should enjoy the accoutrements of age rather than the picture itself. The only defence of 'antiquarian neglect' is that it can be a form of preservation in itself, though the painting's aesthetic existence will be impaired, hidden away behind a heavy screen.

More frequently, antiquarianism has taken the form of partial and irregular cleaning. The danger here is that some details can be obscured, while others are inadvertently and disproportionately highlighted, the net effect being to distort the overall balance of the painting. Figures might suddenly start out of a landscape from the obscurity of a deep brown background. The result will be the same whether the figures have been over-cleaned, or the land-scape under-cleaned: the artist's original intentions will have been betrayed. Patches of uneven, old varnish, left in the hollows, can also falsify the flow of the brushstrokes or give an impression of wear.

Another aspect of the cult of the old is the practice of 'antiqueing' paintings by adding a brown tinted varnish. This was frequently done in the nineteenth century, sometimes even by adding bitumen to the varnish – a particularly destructive practice. The aim of this unnatural intervention was to reproduce the tonal effect of the Claude

[4] André Malraux, *The Psychology of Art*, trans. S. Gilbert, 2 vols (London, 1949).

Glass. Except in the case of unscrupulous antique shop owners or fakers (there is even a product on the market today that will reproduce instant cracks!), this is much less common nowadays.

The search for the 'authentic' takes many forms, from the earnest, archaeological approach, to the adulation of every sort of accidental accretion. This can cause restorers to retouch certain areas (such as blue skies that have gone green) directly over yellow varnish, rather than square up to the task of cleaning the painting at all. The general effect can be similar to that of irregular cleaning, though at least such retouching has the virtue of being easily removed by subsequent generations.

This is not so with the other extreme – systematic over-cleaning dictated by technological fervour. 'Science will never make you see. It will confuse your vision by its necessarily inexact theories' – in the words of the nineteenth-century French painter, Dinet.[5] The main problem today is the routine, unimaginative stripping of paintings, square by square, picture by picture. One of the standard replies to critics of radical cleaning is that the painting was already a ruin, but that its sorry state was only revealed after 'treatment'. This can indeed be true: but where then is the gain?

Today's restorer may give a sigh of thankfulness for his nineteenth-century precursors. They made mistakes too, but in general they were mistakes on the right side, and left pictures with a future even if they were temporarily distorted. (Much of the criticism at the time was aimed against the re-painting of pictures – which was usually reversible – rather than against over-cleaning – which was not.) In contrast conservators may feel despair when they are confronted with a picture which has been through the whole ruthless mill of contemporary technology.

[5] E. Dinet, *Les Fléaux de la Peinture. Observations sur les vernis et les couleurs* (Paris, 1905).

Contemporary fashions are all the more reprehensible since we were warned against the dangers they involve by innumerable men of accomplishment and discernment in previous centuries. We have seen the grand remonstrances of Baldinucci, Goethe, Goya and Delacroix. But there was plenty of more specific criticism, too. Raimondo Ghelli, a Neopolitan connoisseur, deplored the over-cleaning of Titian's *Danae* in Naples in 1788. He complained that the picture had lost all its original beauty, made up of the shadows, the lights and the final touches that only Titian could put on his completed works: 'We shall not see the like of them again.'

Ghelli goes on to pinpoint the damage to the last touches, and he regrets in particular the removal by 'corrosives' of the hair that once fell gracefully over the forehead of Danae. He was also an acute enough observer to notice that the repercussions of over-cleaning went further than the removal of glazes:

The contours are too hard. Never again shall we see the soft tints, and the half tints of Titian. The shadowy clouds which came forward and enveloped the little putto have been carried off by the corrosives, darks have changed, and where previously we saw a column now we see a pilaster. Thus if we now put ourselves in front of this picture of Danae [a late work of Titian] and of the *Venus and Adonis* of Titian's middle period, which has not had the disgrace of being stripped, this latter picture, which was in second place to the ruined *Danae*, is now first, while the *Danae* no longer looks like Titian.[6]

The last remark is particularly suggestive. Not only are the finishing strokes of a work (epitomised in the Renaissance concept of 'sprezzatura' – a seemingly effortless brilliance) the most evident proof of the artist's genius; but in the case of many painters (though not, as it happens, Titian himself) they were sometimes the only work, apart from the preliminary sketch, which was done by the hand of the

[6] Raimondo Ghelli, *Giornale delle belle arti*, 1788.

master himself. Hence their removal can leave us with a painting that is little more than a studio work. It is surprising that this aspect of over-cleaning is not borne more closely in mind by owners and dealers today. They should remember that, in his price list, Rubens costed his pictures according to the extent of his own participation. He wrote in 1618 to Sir Dudley Carleton:

your Excellency having chosen only the originals, with which I am perfectly content: yet your Excellency must not think that the others were mere copies; they are so well retouched by my hand that it would be hard to distinguish them from originals, not withstanding which they are assigned a much lower price.

Ghelli's comment on the transformation of a rounded column into a flat pilaster is also revealing. The point reminds us that damage by overcleaning is not confined to colour and balance, but extends to the third dimension of paintings as the modelling is simplified through the erosion of rounded form by strong solvents in insensitive hands. Ghelli is highlighting a more general problem: the changes in perception of a third dimension at different stages of the cleaning process. An unrestored painting, still covered in discoloured varnish, has a flat look. This is because a yellow and crystallised varnish will lighten all dark colours robbing, for example, the deeper reds or blues of their richness; but it will also darken the lighter colours, giving translucent flesh tones a uniformly bronzed look. As this old varnish is thinned, the third dimension suddenly reappears: roundness and plasticity grow and swell, and perspective effects start to shoot into the distance.

So satisfying is this change that the temptation to continue can be powerful. But should the restorer succumb – as he frequently does – the effect will be reversed and a new flatness will re-emerge as the patina and the glazes begin to disintegrate under the swab. Relining with new

canvas, and the crushing of the impasto which often accompanies this operation, reinforces these distortions.

Ghelli also saw that another result of excessive cleaning was the hardening of contours, which goes together with the loss of the third dimension. In this case, it may be the outline of a leg which has become more harshly pronounced, but other typical examples include trees on a horizon which have become too stark, or profiles which lose their roundness and begin to look like cut-outs. These side effects are all the more lamentable, since major artists have always given immense thought and effort to the problem of defining form without flattening it, constantly striving to give the impression of volume continuing beyond the apparently finite line. Leonardo's *sfumato* was an attempt to overcome this problem. A Renaissance commentary on the classical work of Vitruvius on the subject defines it thus:

> The perfection of art is to make the outlines in a soft manner and sfumati so that one can understand what one cannot see, which is the softest disappearance, a delicacy on the horizon of our view that is and is not.[7]

Innumerable solutions to the problems of line range from the lucidly indefinite limits of Vermeer's forms, to Ingres' view that is should be possible to convey even smoke by a line. Degas, who studied the new aspects of line revealed by photography, such as blurring, foreshortening and varied focus, wrote: 'in painting you must give the idea of the true by means of the false.' It is sobering to think that a combination of brisk, matter-of-fact conservation and indiscriminate chemicals can destroy the fruits of so much reflection and artistry.

Over-cleaning thus damages a picture in every sense: its

[7] Daniele Barbaro, *I Dieci Libri dell' Architettura di M. Vitruvio* (Venice, 1556). Quoted by Professor Ernst Gombrich in 'Blurred Images and the Unvarnished Truth', *British Journal of Aesthetics 2*, 1962.

physical composition, its illusion of volume, and its 'sprez-zatura'. Flesh painting, with its reliance on light and shade to convey rippling transitions, is especially vulnerable. Everyone has been struck by the discordant rawness of some areas of skin in certain newly-cleaned old master paintings. This is not because we are unused to seeing the picture 'as it really was', but because it has been deformed by the suppression of its all-important modulations. A musical metaphor would be as if Raphael, with his 'perfect pitch', were to be interpreted by a tone-deaf restorer.

Negative Examples

Unfortunately, despite Sir Ernst Gombrich's warnings and the evidence of other expert eyes, the policy of over-cleaning has continued to be widespread, particularly in the United Kingdom and the United States. The National Gallery went ahead with the extensive, and in the view of many international experts, alarmingly thorough overhauling of Titian's *Bacchus and Ariadne*. The painting was already considerably damaged with a good deal of old repair and overpainting. But in the view of many informed critics its systematic and unimaginative cleaning has resulted in a tragic disruption of the fragile tonal unity of the painting.

More recent examples include some of the Watteaus in the Wallace Collection. Watteau was a notoriously complex and unorthodox technician. Restoration of his paintings must therefore be approached with even more than the usual prudence. Their rarity is yet another reason for caution. Visitors to the Wallace Collection will now be able to contrast uncleaned with over-cleaned paintings. The latter are, in my opinion, unhappily poignant examples of routine servicing: the sadly familiar sterile, raw, flattened surfaces, hardened contours and rubbed final touches and transitions are especially distressing in Watteau's case. The

delicacy of touch with which he conjured up his idylls is easily expunged. It is difficult to think of an artist whose work is likely to suffer more from the institutional approach.

But there are in Britain and the United States many similar tragedies from other schools of painting. The nineteenth-century Frenchman, J.-F. Millet, was another unorthodox technician whose ability to build organic, accretive effects on the surface of his work made him not only a distinctive artist in his own right, but a 'painter's painter' too, who had a great influence on the Impressionists. Yet many of his most famous paintings are today ghosts of what Millet himself meant them to be. The fate of these pictures at our hands is a dramatic illustration of the conflict of cultures between ourselves and previous centuries.

Millet was a passionate, intense and rather violent man, and we know a lot about his attitude to painting. He has told us that he was trying to express 'nature' and man's 'struggle with the earth', to 'grope into the bowels of it with constancy and labour'. We know that the artist was fascinated by the subtlest of distinctions of colour in the earth itself, or even in old clothing. He kept fragments of cloth in different degrees of fading 'from the crude indigo of the new blouse to the delicate tone of garments that had grown almost white by washing'. We also know what people at the time thought about his work. The great French writer Huysmans once commented on his paintings:

Brute matter, the earth itself, rises out of the framework, alive and exuberant. We feel it thick and heavy; through its clods and grasses we feel it running deep and full. We breathe the scent of it, we can crumble it between our fingers. In most pictures the soil is superficial; in Millet it is deep.[8]

The passion that inspired his painting led to its use (against

[8] J. K. Huysmans, *Certains* (Paris, 1889).

physical composition, its illusion of volume, and its 'sprez-
zatura'. Flesh painting, with its reliance on light and shade
to convey rippling transitions, is especially vulnerable.
Everyone has been struck by the discordant rawness of
some areas of skin in certain newly-cleaned old master
paintings. This is not because we are unused to seeing the
picture 'as it really was', but because it has been deformed
by the suppression of its all-important modulations. A
musical metaphor would be as if Raphael, with his 'perfect
pitch', were to be interpreted by a tone-deaf restorer.

Negative Examples

Unfortunately, despite Sir Ernst Gombrich's warnings and
the evidence of other expert eyes, the policy of over-cleaning
has continued to be widespread, particularly in the United
Kingdom and the United States. The National Gallery went
ahead with the extensive, and in the view of many
international experts, alarmingly thorough overhauling of
Titian's *Bacchus and Ariadne*. The painting was already
considerably damaged with a good deal of old repair and
overpainting. But in the view of many informed critics its
systematic and unimaginative cleaning has resulted in a
tragic disruption of the fragile tonal unity of the painting.

More recent examples include some of the Watteaus in
the Wallace Collection. Watteau was a notoriously complex
and unorthodox technician. Restoration of his paintings
must therefore be approached with even more than the
usual prudence. Their rarity is yet another reason for
caution. Visitors to the Wallace Collection will now be able
to contrast uncleaned with over-cleaned paintings. The
latter are, in my opinion, unhappily poignant examples of
routine servicing: the sadly familiar sterile, raw, flattened
surfaces, hardened contours and rubbed final touches and
transitions are especially distressing in Watteau's case. The

delicacy of touch with which he conjured up his idylls is easily expunged. It is difficult to think of an artist whose work is likely to suffer more from the institutional approach.

But there are in Britain and the United States many similar tragedies from other schools of painting. The nineteenth-century Frenchman, J.-F. Millet, was another unorthodox technician whose ability to build organic, accretive effects on the surface of his work made him not only a distinctive artist in his own right, but a 'painter's painter' too, who had a great influence on the Impressionists. Yet many of his most famous paintings are today ghosts of what Millet himself meant them to be. The fate of these pictures at our hands is a dramatic illustration of the conflict of cultures between ourselves and previous centuries.

Millet was a passionate, intense and rather violent man, and we know a lot about his attitude to painting. He has told us that he was trying to express 'nature' and man's 'struggle with the earth', to 'grope into the bowels of it with constancy and labour'. We know that the artist was fascinated by the subtlest of distinctions of colour in the earth itself, or even in old clothing. He kept fragments of cloth in different degrees of fading 'from the crude indigo of the new blouse to the delicate tone of garments that had grown almost white by washing'. We also know what people at the time thought about his work. The great French writer Huysmans once commented on his paintings:

> Brute matter, the earth itself, rises out of the framework, alive and exuberant. We feel it thick and heavy; through its clods and grasses we feel it running deep and full. We breathe the scent of it, we can crumble it between our fingers. In most pictures the soil is superficial; in Millet it is deep.[8]

The passion that inspired his painting led to its use (against

[8] J. K. Huysmans, *Certains* (Paris, 1889).

Millet's will) as a symbol of Socialism during the Paris Commune, and indeed ever since. Its themes were often reflected in the wonderfully rugged impasted texture of his pictures, once compared to shagreen leather. They were built up from pigments derived from the earth itself: ochres, siennas and umbers in careful tonal contrast. Millet deliberately painted in a shadowy studio: 'It is that half-light that I need to make my sight keen and my brain clear.'[9] The powerful impact of his work comes from his almost religious reverence for nature. In a sense, he was attempting to compete with it in representing the subtlety and multifacetedness of patina and organic growth. His technique was itself a restlessly accretive process, using transparent layers on opaque, and then opaque again over varnish:

> I try to make things seem not put together by chance, and for this one occasion, but so that they have an indispensable and compulsory connection. A work should be all of a piece.

Many of his works found their way to America at the end of the nineteenth century. The first change was thus climatic. The paintings were removed out of their natural and original climate into one quite different, with much greater extremes of hot and cold, dryness and moisture. The second change was due to the workings of time. By the early twentieth century, the paintings would have already developed physically: cracks would have begun to afflict the underlayers of paint, which were too rich in oil, and started to splinter the thinner glazes on top of the picture too. The varnish Millet himself had put on at the vernissage of the Salon, when he may also have made a number of final adjustments, would have yellowed as well.

But the major, irrevocable change and damage to some of these paintings can, it seems, only be attributed to the various restorations they had undergone during their lifetime. We can only speculate on how and when any such

[9] Edward Wheelwright, 'Recollection of Millet', *Atlantic Monthly*, 1876.

damage was done, and it would be unfair to blame individual conservators, technicians or museums. But by the time they were exhibited at the Millet centenary exhibition of 1976, many were radically altered pictures. Again, we can only guess at what they had suffered. But judging by their appearance, they seem at some stage to have been saturated with sophisticated solvents, which probably had the effect of swelling and softening Millet's intricate layers of paint. There was often varnish above and beneath the brush-strokes with which he had deliberately built up his contrasts of opaque and transparent films. It may be that ultra- violet light had been used to ensure that no scrap of varnish had remained. In any event, in many cases restoration had clearly been persistent to the point of removing all the perfecting layers until a hard base had been reached. The flickering touches of luminous colour that were an important pre-figuration of Impressionism were frequently eliminated. Where now was the earth that Huysmans had seen rising out of the picture frame 'alive and exuberant'?

Many pictures had also been flattened at some stage – probably during relining, possibly accompanied by impregnation with wax under heat. By whatever means, the tones had been reduced to a narrower, blander range. Millet's humble yet heroic peasants no longer pursue their time-honoured tasks, till the recalcitrant soil, or stride darkly across the countryside with a sort of grim, primal force, but sink greyly down into the crushed uniformity of their surroundings. The further the restorer's hand had gone, the more out of focus the images had become. Where there was earth, it is no longer heightened by a thousand distinctive brush-strokes calculated to arouse all the senses of touch, sight, and even smell.

Finally, a 'contemporary' look had been given to many of these pictures when they were covered with matt, synthetic varnish. The richness and complexity of an earlier culture had thus been neatly neutralised for modern tastes,

and the pictures hygienically packaged in plastic, like specimens to be catalogued rather than works of art to be enjoyed. Other parallels suggest themselves: just as more pungent tastes are removed from supermarket products, so the forces of entropy are constantly at work to dull down the exceptional in the great painting of the past.

The Golden Mean

In restoration, it is as hard to define the Aristotelian golden mean of virtue as it is in other areas of life. Techniques differ widely, as do national styles. But there are some objective criteria and guiding principles: restraint, reversibility, and an awareness of the bias of our own times. Restraint should spring from respect. No restorer can fail to be impressed by the sheer craftsmanship of the great periods of painting. It is something we are not able to reproduce, and frequently unable to comprehend.

This awareness of doubt should itself be another reason for caution. Schools of restoration continue to contend fiercely amongst themselves over the defenceless relics of the past. But there ought to be much more common ground between them. Just as the artist has to keep a constant tension and interaction between his idea and the practical touch upon the painted surface, so the restorer must balance the whole against the obsessional cleaning of details. Every artist is aware of the importance of maintaining the unity of the painting. But in restoration, too, there comes a point when this wholeness can suddenly fall apart. This does not necessarily mean that there is any colour on the restorer's swab, or that a form or line has disappeared under his scalpel or solvent. A wider judgement is at stake: a moment arrives when a whole nexus of tensions has been breached, and disparate elements no longer hold together. This moment of sudden disunity is

distressingly evident visually, but not easily analysed chemically. Nor can the picture be reconstituted merely by repainting. A similar moment occurs when unskilled or gross retouching overbalances into cosmetics, or even fraudulent manipulation of the original.

An equivalent dislocation can be seen when a room which has aged intact is repainted. Modern paints are many times brighter and more opaque than old materials. Inigo Jones' Banqueting Hall in Whitehall is an instructive example of the unforeseen repercussions. The gleaming modern white reduces Rubens' inset ceiling paintings to dark squares which the eye has difficulty in penetrating. It is worth contrasting the double cube room at Wilton House, never repainted, where the soft, slightly transparent seventeenth-century white paint on the walls does not oppress the Van Dycks hung on them. Another example of a room in which all components have aged together is Robert Adam's long library at Syon House. Here leather, textiles, paint and wood have all matured but the meaning of the room is far from faded. On entering one's breath is caught by the beauty of its unity. To alter one factor in this room would be to alter the whole.

Restraint means, first and foremost, reversibility. In theory this is one of the few universally acknowledged maxims of the profession. Yet it is usually respected much more in the rebacking and retouching of paintings, than in the crucial field of cleaning. It is of course vital that the adhesives used in attaching a new canvas to a picture are removable and do not damage the painted surface. It is equally self-evident that the missing eye in a portrait should be repainted in between a sandwich of varnish, so that there is no practical or ethical confusion with the original, and so that it can be easily removed later. But much of this will be of little avail if the surface of the work itself is mercilessly abraded, its texture ravaged or the surviving evidence of the artist's genius erased. In practical

terms this means simply knowing when to stop. The restorer must also guard against the temptation to make quick advances in one area which cannot be matched in another. Balance and coherence are vital in this mysterious field, where a touch on one side of a painting can profoundly affect another quite untouched area.

Overlaying all these technical problems, and setting a context in which the restorer should work, is the imperative of historicity. These are not just words. The gap between the attitudes and ideals of a sixteenth-century Renaissance painter, and a twentieth-century technician, is unbridgeable. There is surely no doubt about whose will should be given greatest weight. The philosophical illusion of seeing one's own time as timeless, a sort of contemporary eternity, is reinforced by dubious claims of scientific neutralism.

The Relativities of Light

One central area where the principle of historical relativity in painting is most pronounced is that of light. The simple truth that before the mid-nineteenth century pictures were painted in darker studios for display in darker surroundings is too often forgotten. Until that time, light was perceived as emerging from darkness, and people lived the greater part of their life in some degree of shadow. In painting light was often depicted as a kind of blessing – a manifestation of the divine presence. Today we are for the most part bathed in continuous illumination, most obviously in the studio and the picture gallery. It follows that the vision of the 'pre-electric' generation was more attuned to subtlety and graduations of light in life, and so in painting.

As a result, the source of light was more vividly sensed, and its course charted through infinite reverberations into the shadows. Today there is often no evident source at all.

The effect of light on colour and line through different thicknesses of air into the distance was studied by Leonardo. He advised that 'when you draw from nature, let the light come from the north where it doesn't vary. But if it is the middle of the day, keep the window covered with a curtain.'[10] In his writings, he imagines a studio with the walls painted black and a slanting roof with openings to let in shafts of light. The tenebrists of the seventeenth century actually carried out this idea. According to Bellori, an Italian art critic of the time, Caravaggio placed his models in dark rooms exposing them to a light placed very high up, which struck only the principal parts of the body, leaving the rest in shadow, so providing strong contrasts between dark and light.[11] As we know, the result caught the enthusiasm of generations of painters. Caravaggio may even have used torches and reflectors; certainly his many followers throughout Europe, such as Georges de la Tour, were fascinated by the artificial light of candles or torches.

Classicists, like the Carracci or Poussin, have always shunned such dramatic effects. The studios and academies of the painters of the late seventeenth and eighteenth centuries used reflectors to mute and distribute more evenly the light which still came from above. Even artists such as David, who used only natural light, had it placed high and shaded with blinds.

The Romantic studio, by contrast, was a dark sanctuary and shadowy refuge from normal light, or life. Delacroix's painting of Michelangelo in his studio, troubled by the phantoms of his own creations, typifies the mood. Even the dim recesses of Courbet's *L'Atelier* in the mid nineteenth century seem to contain shadowy apparitions, as well as visitors. But already with Seurat and Matisse we are in a different world where shadows have been banished, or

[10] Leonardo da Vinci, *Trattato della Pittura*.

[11] Giovanni Pietro Bellori, *Le Vite de Pittori, Scultori et Architetti Moderni* (Rome, 1672).

serve a quite different decorative function, and where surfaces are flattened by uniform brilliant illumination. The huge windows of late nineteenth-century and twentieth-century studios, and the practice of painting out of doors, show that, for such artists, it was impossible to have too much light. When painters before this period talked about light and dark, they were therefore thinking on a wholly different scale.

Most forms of light were also very much less purified and standardised at that time. When the great Florentine theoretician, Alberti, like many painters since, remarked that 'paintings had a peculiar grace when viewed in a mirror',[12] he was talking of mirrors which, like glass at the time, were tainted by all sorts of impurities. If this is coupled with the lack of a strong, steady, even source of light, and the deeper tone of the varnish on the painting itself, it is reasonable to conclude that Alberti's admiration must have been bestowed upon an object that might seem to us today to be bathed in intolerable obscurity.

The practical lesson for the conservator is clearly not to attempt to compensate for this lost setting in which the painting was first conceived and viewed by simply coating paintings in thick dark varnish, or leaving them encrusted in dirt. But neither should he seek further to reinterpret the original for the modern eye, with its inbuilt bias in favour of stark, flattening light. The anachronistic illumination in which old masters are seen – and restored – in galleries today should surely be enough to satisfy twentieth-century appetites, without doctoring the pictures themselves.

The same is obviously true of artists' materials in general, which were far less refined and 'clean' than modern products. An extreme example would be the varnishes which were made by dissolving amber in oil, and which were subsequently applied by hand. One can only guess at the impurities they contained by that time. Dürer thought

[12] Leon Battista Alberti, *Della Pittura* from *De Re Aedificatoria* (Florence, 1485).

that he had discovered the perfect light varnish. Naturally, he was comparing it with the standards of the time. By our standards it was probably yellowish. Nowadays, as we struggle for ever clearer, whiter, purer varnishes to apply to these very paintings, we would do well to keep these relativities in mind.

The Other Side of the Picture

It is an ironic fact that the most solid advances in the field of conservation have been to do with the back of the painting rather than the front, no doubt because the area is more susceptible to problem-solving techniques. Indeed the ingenuity and expertise lavished on the reverse of a painting often produce minor masterpieces of technology in their own right – except where the resolution of a problem on the back is at the expense of the painting on the front.

In theory, of course, the preservation of the support (canvas, panel, paper or wall) should be entirely aimed at the conservation of the image itself. There is little value in a well-preserved piece of canvas or block of wood. Fortunately improvements in the past few decades have made it possible to do this with the minimum disturbance to the surface texture. Traditionally, fragile or damaged canvas was reinforced with another cloth glued on behind under pressure from an iron. The risks were manifold. The most obvious were the flattening of the impasto by the iron, and blistering or even partial melting of areas of paint when the heat was incompetently applied. Few paintings have escaped entirely unscathed. A further hazard arose as the glue became brittle, and successive relining became necessary. The weakened glue would have to be scraped off and replaced with another relining periodically through the centuries. Heavy-handed scraping could shatter the front.

Crushing of the painted surface in relining by heat and vertical pressure can now be avoided by cold catalyst adhesives, applied without heat under vacuum pressure within a soft, flexible plastic envelope which follows the irregular third dimension of the impasto. The effect is that of a tight, form-fitting, dress. Such methods, amongst the most successful developments of contemporary conservation, can help preserve the finest, most sensuous impasto remaining from the Venetian High Renaissance, or the swirls of modern action painters, sometimes up to half an inch thick.

Relining can consist simply of affixing a new canvas to reinforce a weaker one; but it can also be used to consolidate the picture itself by impregnating all its layers with the adhesive used to apply the new backing, soaking the whole package like butter in a toasted sandwich. There is an enormous variety of such adhesives to suit different purposes. Traditionally, paintings have been relined with animal based glues: rabbit skin, or the rare, but particularly effective, sturgeon's glue. (The only place where this is used is in Russia, where it has been treated with as much respect as caviar itself. Its export was forbidden by the Tsars, and it is still difficult to obtain, although its chemical equivalent, isinglass, is an alternative.) In the hands of an expert craftsman with a measured control over the strength of both the adhesive and the painting, and much sensitive sleight of hand, firm consolidation of flaking paint as well as relining can be achieved with glues of various traditional types with a minimum of distortion of tone. The many new glues emerging as valuable offshoots of commerical developments in other fields, have their own individual qualities and advantages, but have not yet acquired the necessary accompanying expertise with its moderating wisdom derived from long experience. However, many of these new techniques and materials are gradually being proven in practice, and can be of great value, particularly in the treatment of recent paintings.

The use of wax for relining is much more recent, dating only from the last half century. It is an extremely stable substance. Mixed with resin and applied with heat, it permeates the whole sandwich reinforcing all the layers of a brittle or friable picture. In carefully selected cases, skilled use of wax relining and impregnation is an excellent means of holding together a badly desiccated and flaking painting. In these circumstances, wax can be a gentle alternative to strong glues for affixing a lining canvas. It is also, of course, a moisture barrier. Its use on worm-eaten or flaking panel paintings can also be rather less incongruous than on canvas, because of its compatibility with the consistency of the wood itself.

But whatever the treatment, one thing is certain: whatever is done to the back will eventually affect the front. Indiscriminate use of wax can pose serious problems. Its major disadvantage is that it does not pass the reversibility test. Wax is a substance which is not normally present in the rest of the painting, and can deaden its tonality as it soaks into the picture's pores. In dark-toned works, with brown grounds, wax can finally suffocate any surviving half tones that remain visible: the thin transition from eye to cheek in Caravaggesque paintings can easily be completely submerged under its thick, dull weight. Use of wax on light toned, tempera or other unsaturated pastel-like pictures, and particularly on sketchy late nineteenth- and twentieth-century works with much exposed canvas, has irrevocably destroyed their tone and texture. As has already been noted, the Cubists have suffered particularly badly.

Panels have generally stood a better chance of survival than canvas. Their sheer solidity guaranteed a longer life span, provided of course that the wood was well chosen and cut in the first place. Yet they are peculiarly vulnerable to changing atmospheric conditions, which warp or split the wood, and dislodge the paint. Throughout the centuries, attempts have been made to counteract these natural

tensions, sometimes by thinning panels in order to reduce the strength of the warp in the wood itself. Thereafter cradles of crossbars would force the panel to lie flat, though these were only effective if the grain responded naturally to such constraints – in which case they might by definition be unnecessary, so long as stable atmospheric conditions prevailed. Cradles, like so many other restoration methods, have often caused more damage than they have prevented. If the cut of the wood pulls in a different direction, the cradle becomes a straightjacket, forcing the panel, and the painting, into new contortions and producing new cracks.

As in other fields, the most frequent hazard in the treatment of panels is over-reaction. It is by no means always necessary to construct elaborate sliding devices behind the panel painting simply because of a slight, or even a pronounced warp. Everything depends upon a judgement on the stability of the panel, and this can best be secured by constant temperature and humidity control. There is no lack of or limit to, experimental ingenuity – some of it ethically dubious – in this area. It is not unknown for a painting to be floated off its wooden support, and then grafted on to plastic or some other composite substance, thereby completely denaturing the original object.

A panel painting may be twisted by time, but its warp might be stable and undisturbing to the eye. The mere possibility of being able to intervene technologically should not make such intervention a probability. Old panels, like old men, are sometimes bent by nature. Only the prissy will find this unsightly, or unacceptable.

Retouching: Cosmetics or Continuing Aesthetic Life?

Retouching, repainting, inpainting, over-painting – the variety and inexactitude of the terminology is revealing. In

essence, they often come to mean the same thing. But the diffuse vocabulary reflects widely divergent attitudes and practices.

The main tradition has always been that of illusionistic retouching: doing one's best to paint in missing or damaged parts of a picture to make them as difficult to distinguish as possible from the original. But this is not as simple a matter as it seems: there frequently comes a point where, given the balance between lost and original paint, it would be wrong, as well as stylistically unattainable, to make good a significant area of a picture where the artist's intentions can only be surmised. By the time of the High Renaissance, the aims and ethics of retouching were already the subject of controversy and debate.

The central problem – whether to replace major losses, and if so how – is dramatised by the dilemma posed by the gaping holes in much of medieval art. Copious re-painting of such works started as early as the Renaissance. The motives of a good deal of the extensive retouching was often as much to bring medieval pictures 'up to date' as to fill in any gaps. Some of the stern, Romanesque crucifixions or Madonnas at Lucca were softened and 'gothicised' in the fourteenth century by followers of Giotto.

But where the originals survived – as a number did – it was not because they had been consistently preserved. They were more likely to have remained reasonably intact because of the very unfashionableness of 'primitive' art right through to the sixteenth and seventeenth centuries. Some of these old paintings were used as grounds for new pictures – rather as medieval churches were redone in baroque plasterwork – but many were simply ignored, and fell into decay in their chapels or crypts. Once again, neglect was a double-edged phenomenon: although whole areas of paint were lost, at least what remained was spared the distortions and disfigurements of successive waves of conservation.

In the twentieth century, there has been much debate about how to deal with such large losses on paintings, and a number of experiments have been made. The concept of a neutral tone to disguise large losses was much advocated. The problem is that no tone is truly neutral. None offers the variety of natural decay, and all seem to develop a sort of menacing visible presence which oppresses the surrounding picture. Unlike fragments of sculpture, the circumscribed space of the painting is brutally interrupted by a sudden, unexpected hiatus. The eye is irresistibly drawn to it, conditioning the approach to the picture as a whole, and thus producing precisely the opposite effect to that intended. Only within the rather less clearly defined limits of fresco paintings can the natural plaster of the wall occasionally act satisfactorily as an unobtrusive replacement for a loss. It is tempting to conclude, with Leonardo, that nothing can rival the natural random and evocative abstractions of decay in lost areas, whether on a fresco or easel painting. But simply leaving time to take its course is rarely a realistic option: even the retouchings of nature will be deformed by any preservative treatment (impregnation of the paint film, or reinforcement of its support for example).

Whether the technique is illusionistic, or whether an 'abstract' approach is adopted, a key requirement is for a consistent treatment throughout the surface of the painting. Recently there have been some relatively successful developments which meet these requirements while also overcoming the challenge of how to break up the implacably flat, middling tones used to cover the lost paint, without fabricating the original. A brilliantly imaginative and systematically abstract approach was evolved about thirty years ago at the Istituto del Restauro in Rome. Called *tratteggio* (a form of hatching) it consists of parallel lines of pure colour which are painstakingly painted into the missing area. The technique picks up the tradition of parallel hatching used in early Renaissance tempera paint-

ings, with their small brushstrokes and geometrical lines. The same qualities make the method eminently suitable for some modern paintings. When used with discretion and virtuosity, it is invisible at a few yards' distance. Unlike neutral in-painting it does not give a flat or dead effect, but is vibrant in its play of complementary colours, and somehow satisfyingly logical.

But every method has its limitations, and the recent tendency to seek to convert this simple but successful solution to the more sinuous shapes of non-rectilinear schools of painting, such as the Cimabue Crucifix from Santa Croce in Florence (which was based upon the compass rather than the ruler), or to the baroque or rococo curves of later painting is probably stretching the technique beyond what it can reasonably be expected to achieve. In contriving to bend the minute lines to follow the general contours of the painting, the restorer risks focusing attention on the very losses he is attempting to hide with his rather self-conscious and expressionistic interpretation.

Pointilliste-type dots, or a mesh of minute touches of pure colour, can be a possible alternative for schools of painting based on Hogarth's famous theory of the 'curving line of beauty', and have the same advantages as the hatching technique in covering large losses. They also satisfy the same criteria of being intentionally visible on close inspection, but unobtrusive from a few feet away. Their use naturally demands the utmost tact and discretion, and 'abstract' in-painting may be particularly appropriate for paintings with total losses in critical areas, or where the damage is so extensive that retouching might outweigh in some parts of the picture the areas of original paint. In such cases illusionistic repainting would inevitably take on the deceptive and misleading character of pastiche. But all this is only part of the problem: worn or rubbed areas, over-cleaned glazes, or scratched or flaking surfaces cannot be replaced by either lines or dots.

Thus we are invariably brought back to the fundamental need for a judgement, in this as in other cases, on how best to preserve the aesthetic integrity of the original. Archaeological purism – the stark consequences of which can be seen at Yale University Art Gallery, where, in my opinion, a combination of radical cleaning and a dogmatic refusal to retouch even seriously damaged works – is certainly not the answer.

The dangers of illusionistic retouching are very evident, and its excesses have traditionally been one of the most highly criticised aspects of restoration. Yet sensitive and tactful work by definition does not compromise a painting. It would be priggish to deny badly worn pictures some minimal and resolutely unassuming help; just as it would be intolerably self-righteous to resist the natural instinct to render invisible accidental damage or deformity, where the majority of the painting is still intact. A tear across the face of a figure, for example, will induce an involuntary wince in even the most purist observer.

The obvious response – an invisible, imitative repair – has for centuries prolonged our enjoyment of many paintings which to the casual or inexpert eye appear undamaged. It is only when such repairs extend beyond the strict limits of necessity, or when the restorer is tempted by his own virtuosity into encroaching further and further into the original work – strengthening, tidying, or perfecting a hypothetical finish – that the spirit of a painting is sapped. Much that is unexpected, exceptional or mysterious from another age may then be subsumed into the simplified, vision of the modern mode. One important precaution is the keeping of records of the state of the picture prior to retouching – though this should not be used as an excuse for over-extensive work.

In any repainting the restorer must constantly bear in mind the principles and intricacies of layer painting taught in the studios of the early Renaissance. The retouching

mixture on the palette will not equal in transparency a picture painted in layers, which have been slowly built up, giving rich depth to the colours. It is only by following similar principles – though necessarily with different materials – that the restorer can hope to create a persuasive match. In previous centuries interpretative, painterly retouching was carried out, often by fellow artists. Today we are rightly more circumspect. The avoidance of extremes is still the golden rule. We cannot hope to recapture the verve of the original by mimicking the confident individual strokes of the master himself. The only way to echo the inspiration of the artist's original brushstroke is to imitate, with as many inflections as necessary, the single sweep of the painter's hand. But it is equally important to avoid any sense of laboriousness. Retouching is inevitably a painstaking process, but nothing is so deadening to a picture as signs of lengthy and meticulous restoration.

Naturally, extreme care must be taken to confine any repainting to lost areas. This means a very fine brush, and a good deal of patience and time. It can take much longer to restore a damaged picture than it took to paint it. Through bitter experience all restorers learn that nothing can be imitated by short cuts. The first move is to build up the lost area with a filling mixture, taking care to reproduce as closely as possible the impasto and texture of the work as a whole. This includes reproducing the criss-cross effect of the canvas on the filler. The next step is to give the entire painting a thin coat of varnish. The fillings are then covered with a base colour on top of this varnish.

The medium and colours to be used in re-painting are another source of difficulty and occasional debate. Each conservator will evolve his own methods, but there are some essential prerequisites. Although any new paint will be safely sandwiched between two layers of varnish, and thus always removable, it will certainly be desirable to reduce the frequency of treatment as much as possible. This

means ensuring that the colours used alter as little as possible over time; not an easy judgement to make bearing in mind that the artist's own tones will continue to alter too, although much more slowly over a longer period. All retouching media have their pros and cons. Watercolour blanches, oil darkens, varnish may be too transparent, and egg tempera too opaque.

Obviously, the main requirement is that the chosen vehicle must conform as closely as possible to the character and period of the picture. If the retouching is to be truly illusionistic, it must match in texture and mattness, as well as in colour and tone, the paint surrounding it. Some new synthetic resins may have a texture and tone which are compatible with a recent work, but are unlikely to suit a minute seventeenth-century oil painting on copper. Pastel may be the ideal solution for an unvarnished gouache or distemper painting. For most oil paintings, however, a watercolour ground, built up with layers of glazing (varnish plus pigment), is a fair substitute for oil and paint, which suffer from the perennial tendency to darken swiftly after the first application, and to grow more transparent with time. This means of course that the most straightforward response to the problem of retouching – analysing the artist's pigments and following suit – is rarely practicable.

Like nearly all other conservation methods, illusionistic retouching has been much abused. Some restorers have become too adept at it, allowing their own personal 'interpretation' of a picture to intrude to the extent of finishing an unfinished work or totally renovating one that is very worn. Some dealers have a transparent motive in using repainting to embellish or subtly alter the style or period of a painting. There may be some comfort in the knowledge that ultra-violet technology can show up most extensive retouching, even when it is invisible to the naked eye. This, together with its removability somewhat reduces the element of 'fraudulence', except of course to the

uninitiated eye of the visitor to the museum or gallery, or to the potential purchaser.

Regrettably, retouching is sometimes difficult to limit exclusively to areas of actual loss or damage. Previous alterations, such as pentimenti, the effects of ageing and other forms of wear – some caused by over-cleaning – can be equally obtrusive to the eye. A particular crack may attract attention and thereby distort the sense, or a chance pattern of superficial marks may add up to a distracting factor which needs to be muted. The task facing the conservator is to adjust all these so that they are no longer disturbing to the viewer, but sink back into the unity of the whole. None of these problems should be used as a pretext for extensive repainting, and very often much can be achieved by a few judicious touches. One small stroke can have a surprising impact, reinvigorating a dead area by joining two sections of original paint, or evoking a hint of a half-lost glaze. Equally, considerable amounts of wear or damage can be left untouched without causing undue disruption to the entirety of the painting.

But beyond all this, a healthy mistrust of repainting, whether imitative or otherwise, should persist. The restorer must navigate between the Scylla of refusing to touch a painting at all (which in the case of badly damaged pictures can effectively relegate what remains of a living image to the archives of history) and the Charybdis of extensive re-working. There is surely no doubt that, in the conflict between historical documentation and the aesthetic purpose of the work, the latter must dominate. But here, as elsewhere, the sensitivity and honesty quite as much as the craftsmanship of the conservator are essential to strike the final balance. And as with cleaning, so with retouching: the possibility of leaving the picture alone should never be discarded.

Varnish: the Eternal Quandary

As he completes his work, the picture restorer will come up once again against the vexed question of which varnish to use, and how to apply it. In the past, the choice was between various types of natural resin, each with their separate attractions and imperfections. In the 1930s and 40s, it began to seem as if the long-sought elixir of a permanent, colourless coating had at last been discovered. This 'final solution' to an age-old conundrum also seemed to have the immense advantage of sealing the image off for posterity, and so minimising the need for further intervention. The expedient was simply to encase the painted surface in a synthetic, and non-discolouring resin. But already it is all too evident that this has by no means solved the problem.

Aesthetically, synthetic varnishes are simply not compatible with old paintings. Their sheen is that of plastic, and does nothing to enhance the sensuous feeling of the paint. Physically, they are equally incongruous, since they fail to fulfil one of the foremost functions of varnish, which is to saturate the colour, thereby producing this impression of richness. Nor are they permanently transparent: instead of yellowing, these artificial resins produce an optical grey haze, which comes from the failure of the two surfaces – the varnish and the paint – to integrate properly. The effect is that of a plastic cover on a book. An optical barrier is formed, which prevents us looking *into* the picture. This greyness is further accentuated by the tendency of such varnishes to accumulate dust by electrostatic attraction, like perspex.

Countries such as Great Britain and the United States where synthetic resins are almost universally used, seem to consider natural resins as somehow 'unclean' and unreliable. Certainly, even in their modern guise, such resins will

still yellow with time, just as painters always knew that they would. But no artist ever expected his picture to go grey. To remove one of these new varnishes, and to replace it with one made of natural resin, has the effect of a blood transfusion.

In restoration, minutiae matter. Even the way the final varnish is applied can make a surprising difference to the whole appearance of the picture. Conversely, the most authentic restoration can be vitiated by one incompatible element. Sprayed varnish can give an old painting the anachronistic texture of a photographic surface, since it is built up of myriad dots. Varnish applied with a brush – as the artist did himself – may possibly be less even. But it will be one millimetre closer to the picture as it looked when the artist last saw it.

CONCLUSION

In this subtle equilibrium between the false and the true, everything is relative, everything is a question of the more or less. Extreme sincerity runs the risk of being as ridiculous as it is intolerable.

Bonnard, *Observations sur la Peinture*

Why all the fuss? If we are talking about an aspect of visual meaning so remote, so recondite, so hopelessly subjective that it cannot even be understood clearly from a photograph, does it exist at all? And if it does, is it not best to leave this highly specialised affair to the experts?

By and large, that is precisely what has happened, with the results that can clearly be seen today. Bonnard described painting as 'the transcription of the adventures of the optical nerve'.[1] The differences between good and bad restoration are the same adventures, writ small. But one of the reasons I was encouraged to write this book was that concern about conservation is not confined to anxious

[1] Bonnard, *Observations sur la Peinture* (1945).

aesthetes. Perfectly ordinary people, who happen to like looking at paintings, can see that things are not as they ought to be. You do not need a highly tutored eye to know that a piece of drapery, a single foot or an outstretched hand appear to us all to have the most profound solemnity and significance, and people somehow know when that magic is missing, or has lost its meaning. They don't get the right feeling in their 'optical nerve' when they look at a brashly restored picture.

The simple viewer also delights in wonder, yearns for timelessness, and senses in a confused way when he is being fobbed off with the everyday. His disappointment is echoed by professors and cognoscenti, and all are rightly reacting against the flat torpor of mundane contemporary values in a mass age. The more reflective and critical spectator will suspect that the picture has been restored in such a way as to make it more accessible to him, by painting out or cleaning off incomprehensible or unclear passages. He will probably resent this, just as he might resent the rationalisation and reform of our spelling to drop 'redundant' letters or the gutting of our classics to avoid overstraining our children's intelligence.

After such an unprecedentedly intense period of restoration, it is surely time to call a halt for reflection. Yet in many museums and galleries the work of inadvertent destruction is proceeding with ant-like thoroughness. There may even be worse to come: in some ways, the future looks as depressing as the immediate past. There is an alarming expansion in the number of restorers being trained, and new institutes are mushrooming around the world. We could be moving into a period of 'conservation inflation', with too many restorers chasing too few pictures. This could carry its own particular dangers. Already students sometimes cut their teeth on major works of art. As newly trained technicians, they will be all the more eager to test their skills on good paintings, and institutions will be

under pressure to find them something to do. What Reynolds once said about art in general is true of conservation too:

A provision of endless apparatus, a bustle of infinite enquiry and research, . . . may be employed to evade and shuffle off real labour – the real labour of thinking.[2]

Such mechanical activism is dangerously self-justificatory: too much restoration at any one time removes comparative material, thus increasing still further the pressure for uniformity. Meanwhile the element of prestige and competition between the galleries themselves shows no sign of diminishing, any more than the urge to experiment or to invent 'progressive' methods. There are, of course, dozens of major paintings in the galleries of Europe alone which would be improved by the right attention, and some that are painfully discoloured. But the risks of modern restoration styles are such that it would often be better to leave well – or near well – alone.

But in our busy century, inactivity is not to be tolerated. The notion of leaving something alone is in itself revolutionary. It is possible to get away with virtually anything except doing nothing. It is a pity today's restorers do not have the aplomb of Michelangelo, who in reply to criticism of his *David* climbed back on to his scaffolding, chisel in hand, and simply let fall a handful of marble dust. Everyone then agreed that the figure was perfect.

Yet there are some signs of hope. Here and there, there is evidence of second thoughts. The reconsideration by the Washington National Gallery of its cleaning policy, and some discussion in the columns of the *New York Review of Books* have helped to keep the issue alive in the USA. The 1984 Genius of Venice exhibition in London gave rise to a spontaneous debate about the controversial

[2] Joshua Reynolds, *Twelfth Discourse to the RA*, 10 December 1784.

cleaning of the *Judgement of Solomon* by Sebastiano del Piombo (or Giorgione). The Metropolitan Museum of New York has recently had a succession of impressive men at the head of its restoration studio, with John Brealey taking over from Hubert Sonnenberg. The Getty Foundation has also announced that its massive restoration programme will emphasise the need for scientists and art historians to co-operate closely, and has appointed the brilliant Andrea Rothe as the head of its own conservation department.

Anglo-Saxons are said to be allergic to abstraction. Yet we badly need a new philosophy of conservation, which can only be based on historical imagination and critical detachment from the 'spirit of the times'. We could start by reflecting on the words of Joseph Addison, another writer who interested himself in the subject, who wrote this passage in *The Spectator* of 5 June 1711:

I dreamt that I was admitted into a long spacious gallery which had one side covered with pieces of all the famous painters who are now living, and the other with the works of the greatest masters that are dead. On the side of the living, I saw several persons busy in drawing, colouring, and designing; on the side of the dead painters, I could not discover more than one person at work, who was exceeding slow in his motions, and wonderfully nice in his touches Observing an old man (who was the same person I before mentioned, as the only artist that was at work on this side of the gallery) creeping up and down from one picture to another, and retouching all the fine pieces that stood before me, I could not but be very attentive to all his motions. I found his pencil was so very light, that it worked imperceptibly, and, after a thousand touches, scarce produced any visible effect in the picture on which he was employed. However, as he busied himself incessantly and repeated touch after touch, without rest or intermission, he wore off insensibly every little disagreeable gloss that hung upon a figure. He also added such a beautiful brown to the shades and mellowness to the colours that he made every

picture appear more perfect than when it came fresh from the master's pencil. I could not forbear looking upon the face of this ancient workman, and immediately, by the long lock of hair upon his forehead, discovered him to be Time.

INDEX

Index

restorations, 18, 105–6, 111–
12, 115, 136; on colour
and mud, 32; on David, 60;
experimentation, 63; and
Impressionism, 64; and
light, 146; *The Women of
Algiers*, 133
diluents, 34–5, 39, 100, 132
Dinet, Alphonse Etienne,
135
distemper painting, 157
Donatello, 90, 92
Dou, Gerard, 83
Dresden, 86
Duccio di Buoninsegna, 101
Duchamps, Marcel, 20, 71, 76,
81
Dürer, Albrecht, 39, 148
Duveen, Joseph, Lord, 81
Dyck, Anton Van, 144

Eastlake, Sir Charles, 111–12
Edwards, Pietro, 109
egg: as medium, 34
Elgin Marbles, 108
Eyck, Hubert and Jan Van, 37
Eyck, Jan Van, 35, 46–7, 52:
Ghent altarpiece, 101

faking, 18–19, 83–4
Faraday, Michael, 112
Flemish painting, 46–7, 52–3
Florence: 1966 floods, 130; *see
also* Uffizi Gallery
fluorescent paint, 70
Fontainebleau, 105–6
Fragonard, Jean Honoré, 57–8
framing, 86
French Revolution, 60

fresco: and egg yolk, 34; in
classical times, 43, 58–9;
in wall painting, 44–6;
durability, 58; and decay,
153
Freud, Sigmund, 11

Gainsborough, Thomas, 56–7
Garrick, David, 75
Geertgen tot Sint Jans, 89
Genius of Venice Exhibition,
London, 1984, 163
Gérôme, Jean Léon, 37
gesso, 44
Getty Foundation, 164
Ghelli, Raimondo, 136–8
Giorgione (Giorgio da Castel-
franco), 47, 164
Giotto (di Bondone), 152
Giovanni di San Giovanni, 103
Girodet-Trioson, Anne-Louis,
106
glazes, glazing, 35–7, 47; and
patina, 114, 137
glues, 149
Goes, Hugo van der: *Portinari
Altarpiece*, 46–7
Goethe, J. W. von: mistrust of
restoration, 17, 104, 115, 120,
136; on 'powdered doll
painters', 59*n*; on Leon-
ardo's *Last Supper*, 90
Gogh, Vincent van, 67, 87
gold leaf, 44
Gombrich, Professor Sir Ernst
H., 15, 116–18, 139
gouache, 157
Goya y Lucientes, Francisco
de, 104, 115, 120, 136

169